# VANISHED
# SPLENDOR

# VANISHED SPLENDOR

 The Colorful World of the Romanovs

## Robert Alexander

*Illustrations by Christopher Bohnet*

PEGASUS BOOKS

NEW YORK  LONDON

Vanished Splendor

Pegasus Books Ltd
148 West 37th Street, 13th Floor
New York, NY 10018

First Pegasus Books hardcover edition March 2017

ISBN: 978-1-68177-365-0

10  9  8  7  6  5  4  3  2  1

Printed in the United States of America
Distributed by W. W. Norton & Company, Inc.

To tell a story, some writers think in words and try to blow those words up into images. Other writers think in images and use words to capture those images on the printed page. I am of the latter. I can't write a book until the film of the story starts rolling in my imagination. So I suppose I shouldn't have been surprised that capturing Imperial Russia in images for an adult coloring book was not only natural, but also fun. All I (desperately) needed was the talented Christopher Bohnet, part Russian by descent and consummate graphic artist by trade, to make *Vanished Splendor* a reality.

Historically, of course, Russia was a mighty empire of vast inequities. Nicholas II, the last tsar, was the fifth richest person in the entire history of the world, yet the empire he inherited was populated by an enormous peasant population that was 91% illiterate. Consequently, the uneducated population learned of the larger world through the understandable language of their church, the icon. Simply, Russians came to understand their lives and their values through the painted images of saints and sinners. With this in mind, it's no wonder that so much of Russian culture, from its architecture to its arts, presents itself graphically.

In my decades of traveling to Russia I have come to understand that Russians are drama queens from the get-go. They love with all their hearts. They embrace friends like lost relatives. They create buildings, music, art, ballet, fashion and more with mind-boggling creativity. In love and life, they embody the expression: "It's not done until it's overdone."

So what better material for a coloring book than Russian culture? And what better time than the era of the last tsar—often referred to as The Silver Age—when Russia was roiling with change and growth and hope? By all accounts, the Russia of the early 1900s was a nation with one foot firmly planted in the past grandeur of the Romanovs and the other foot searching for a step into the future.

It's with great pleasure, then, that Christopher and I offer up *Vanished Splendor*, which tells the tale—via personal pictures and creative imagery—of an empire once grand, always proud, and now lost.

—Robert Alexander

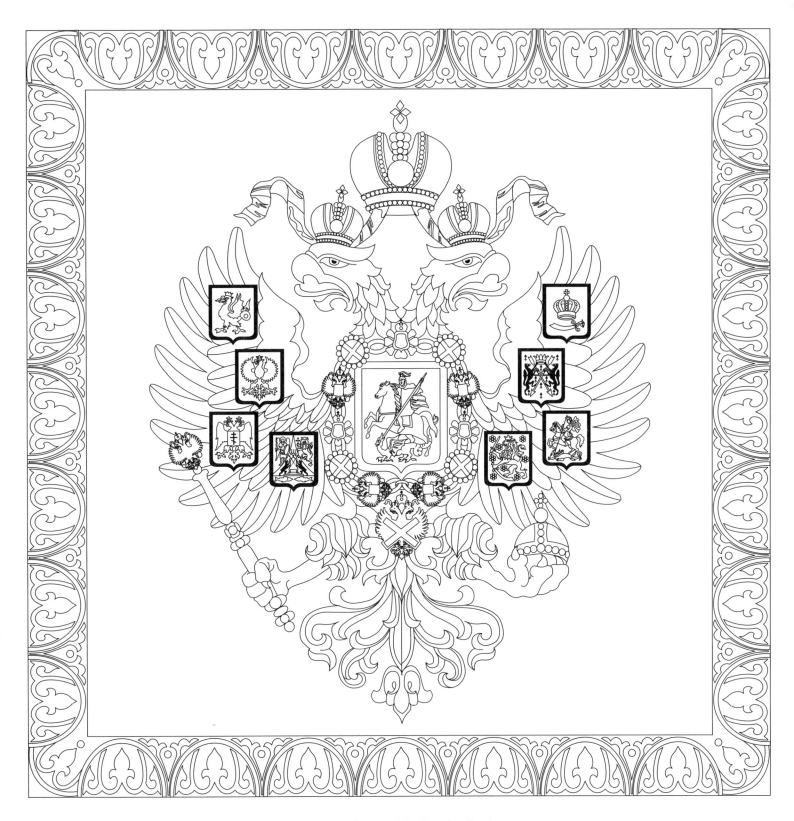

The coat of arms of the Russian Empire.

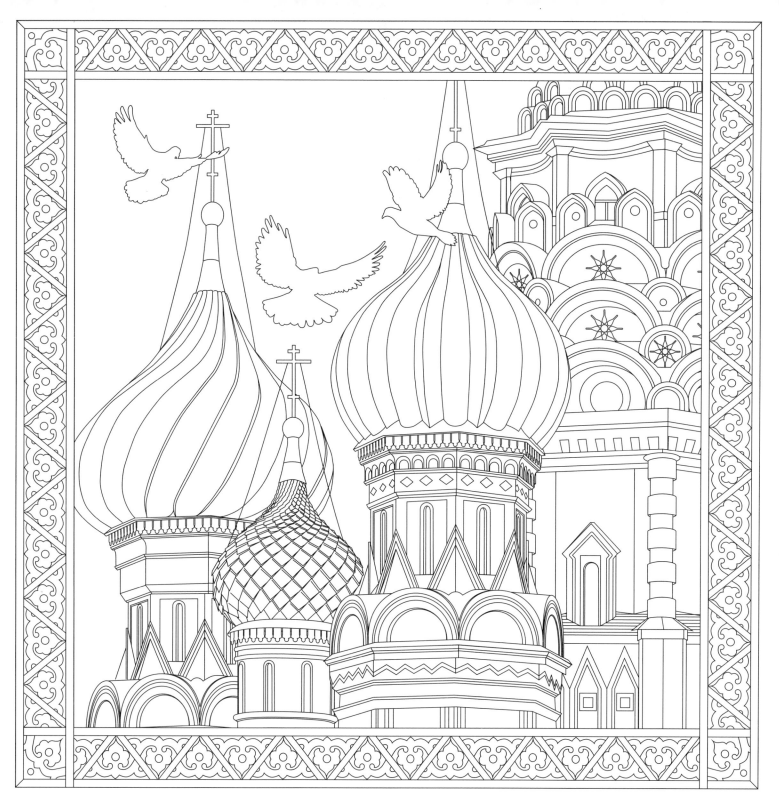

St Basil's Cathedral on Red Square, Moscow. Built by order of Ivan the Terrible in the 16th century, it is a stunning example of Russian architecture's color and creativity.

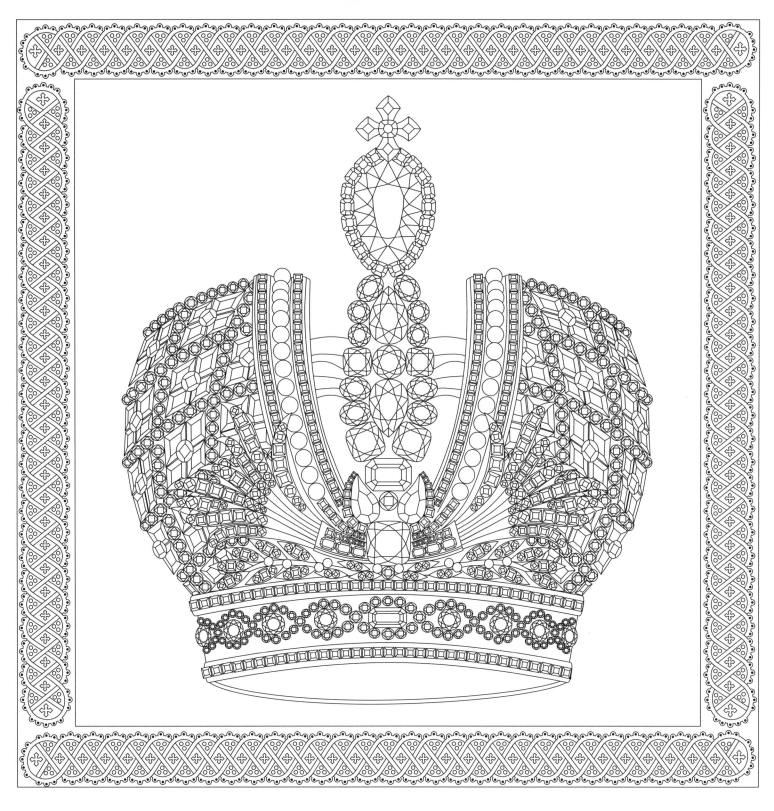

The Great Imperial Crown of Russia, used by every ruler from Catherine the Great to Nicholas II. Lined with red velvet,
it is decorated with a number of pearls, some 5000 diamonds, and a large red spinel of 398.72 carats.

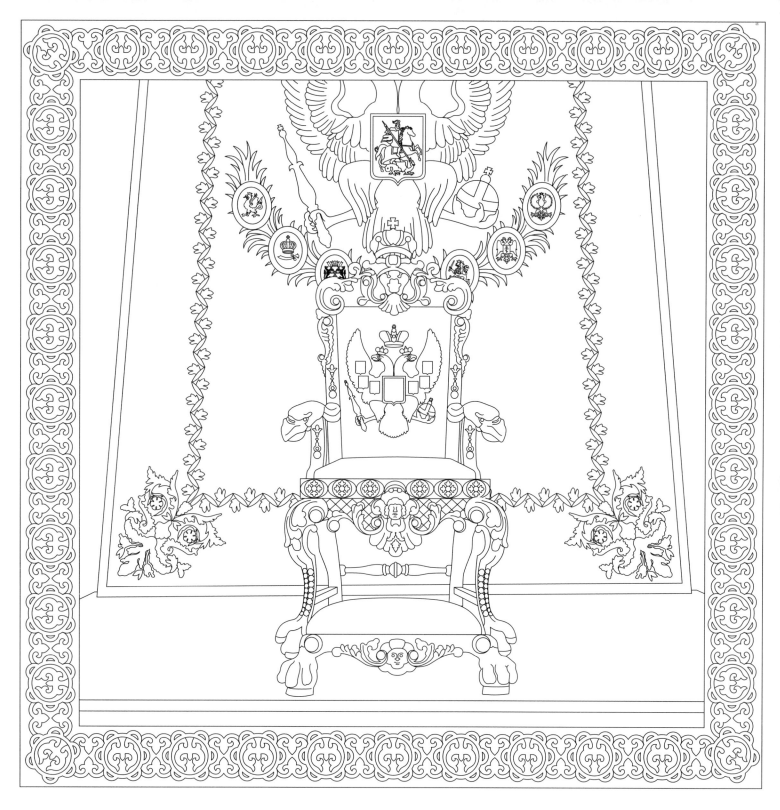

The Imperial Throne in St George's Hall of The Winter Palace. It was commissioned by Catherine the Great and used by every tsar thereafter as the principal throne of the Empire.

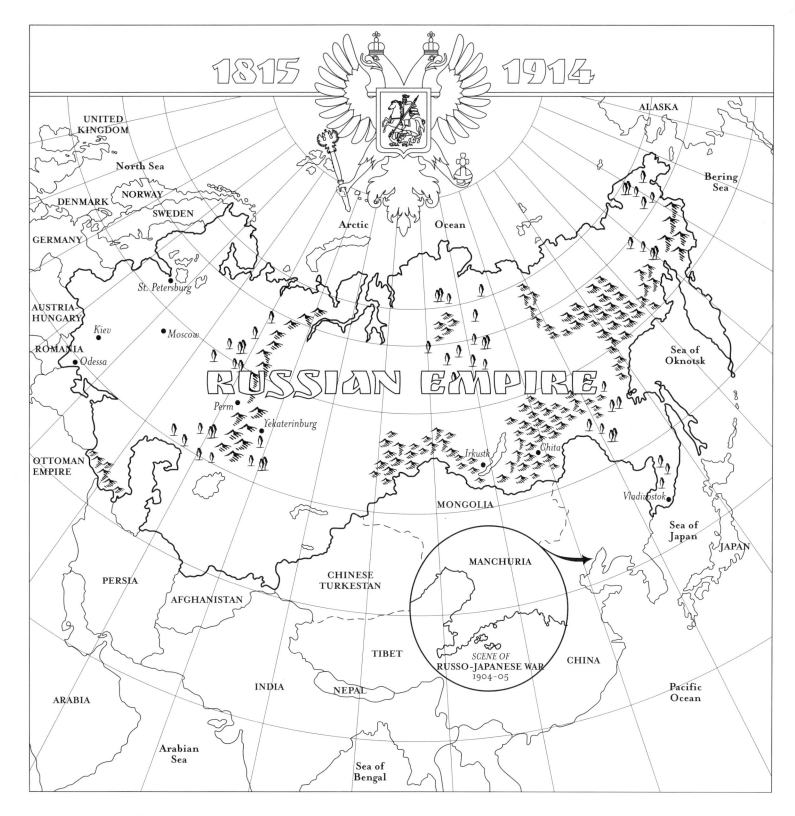

The Russian Empire was enormous, spanning three continents from the Baltic Sea to the Pacific Ocean.

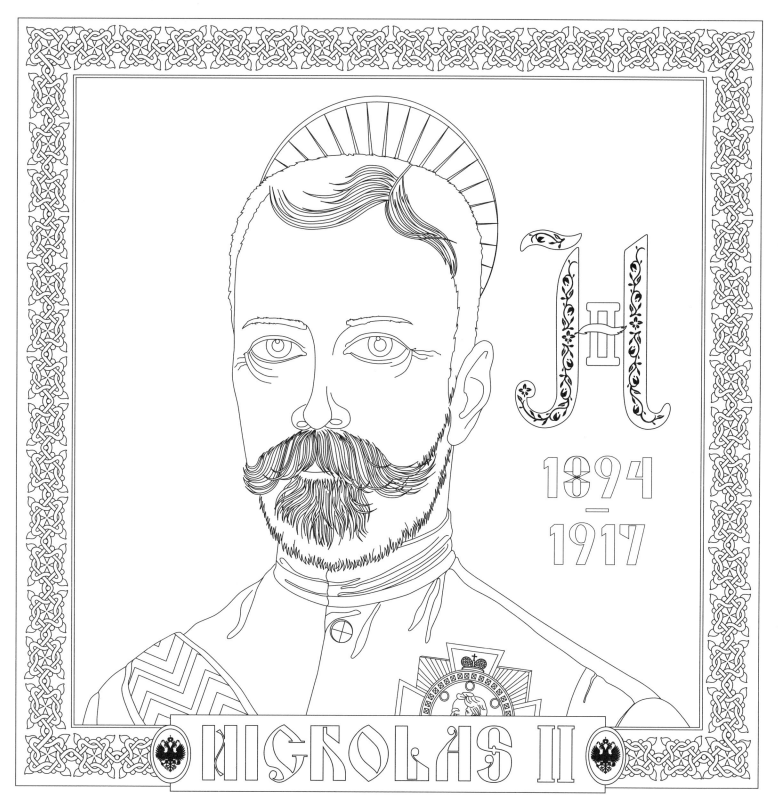

Nicholas II, last Tsar of all the Russias, who reigned from 1894-1917. He and his family have since been canonized as royal martyrs.

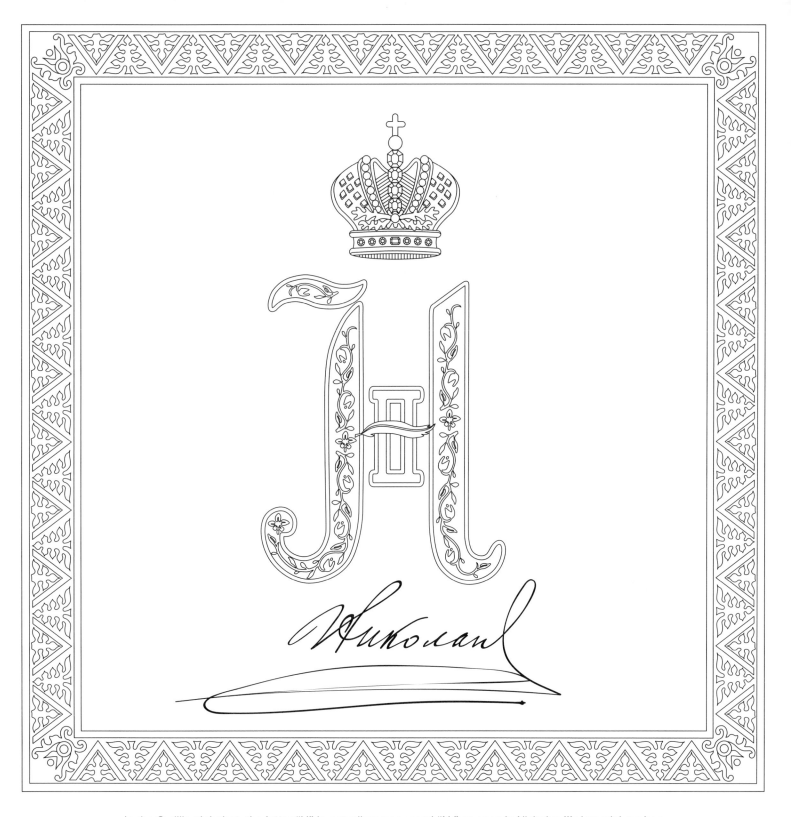

In the Cyrillic alphabet, the letter "H" is actually pronounced "N," as seen in Nicholas II's imperial cypher.

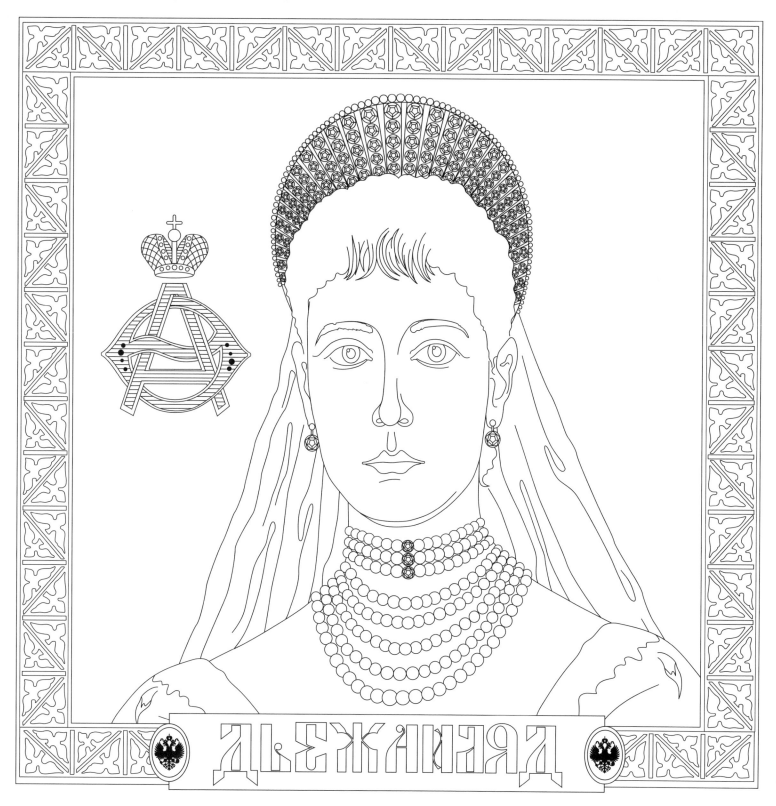

Alexandra Feodorovna, the beloved wife of Nicholas II and the last Tsaritsa of Russia.

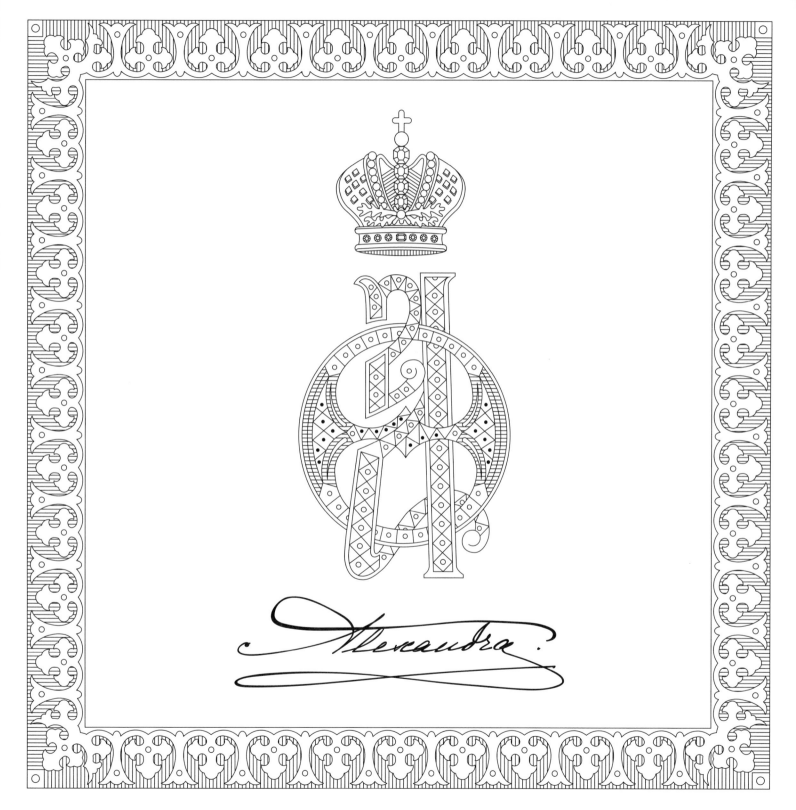

Alexandra Feodorovna's imperial cypher surmounted by the royal crown, signifying she was part of the reigning family.

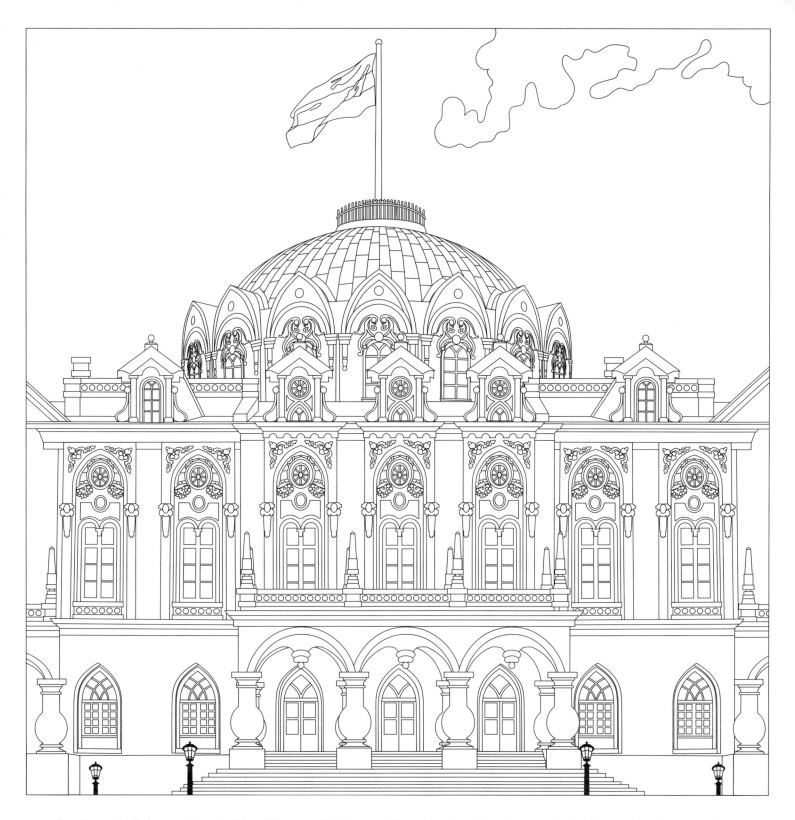

The Petrovsky Palace on the outskirts of Moscow. Nicholas and Alexandra stayed here before entering Moscow for their coronation.

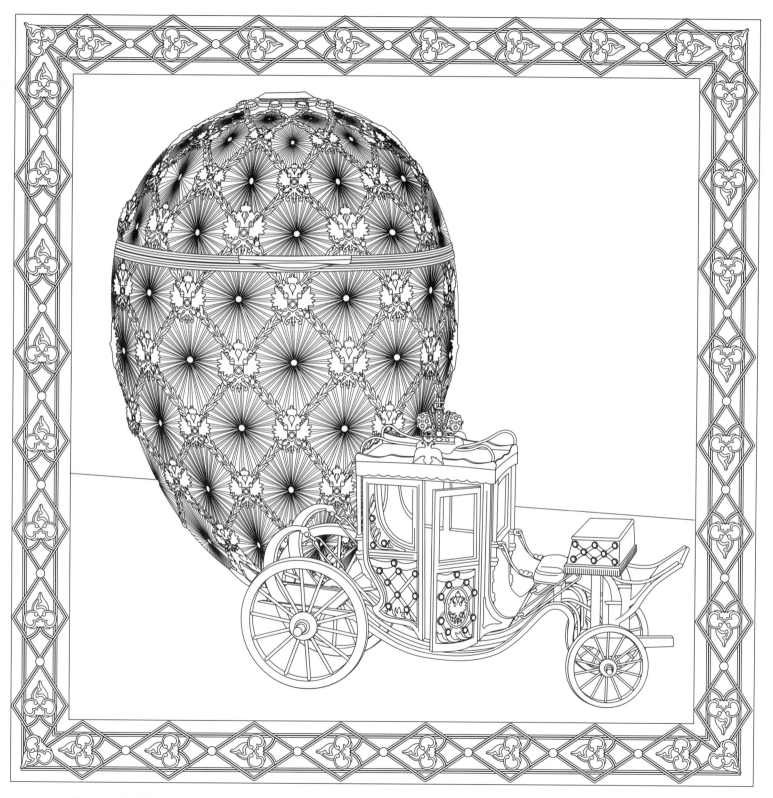

The Imperial Coronation Egg, presented by Nicholas II to Alexandra in 1897. Fabergé crafted this treasure of solid gold with rose diamonds. Inside is a precise replica of the of Imperial Coach crafted in strawberry and blue enamels.

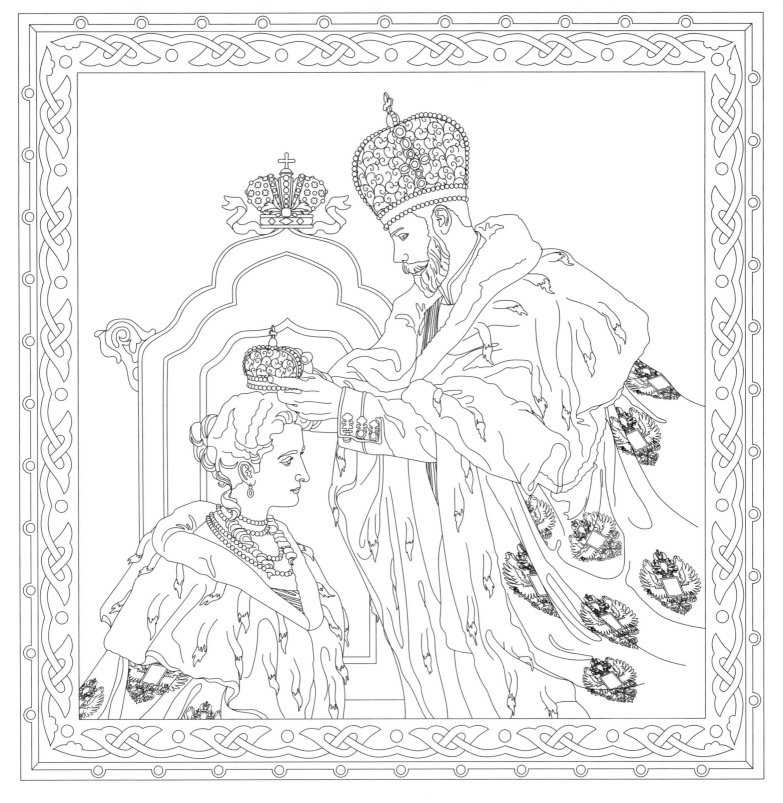

At his coronation in 1896, Nicholas II took the Great Imperial Crown from the Metropolitan and then placed it upon his own head. He then turned and placed the smaller Consort's Crown upon Alexandra Feodorovna.

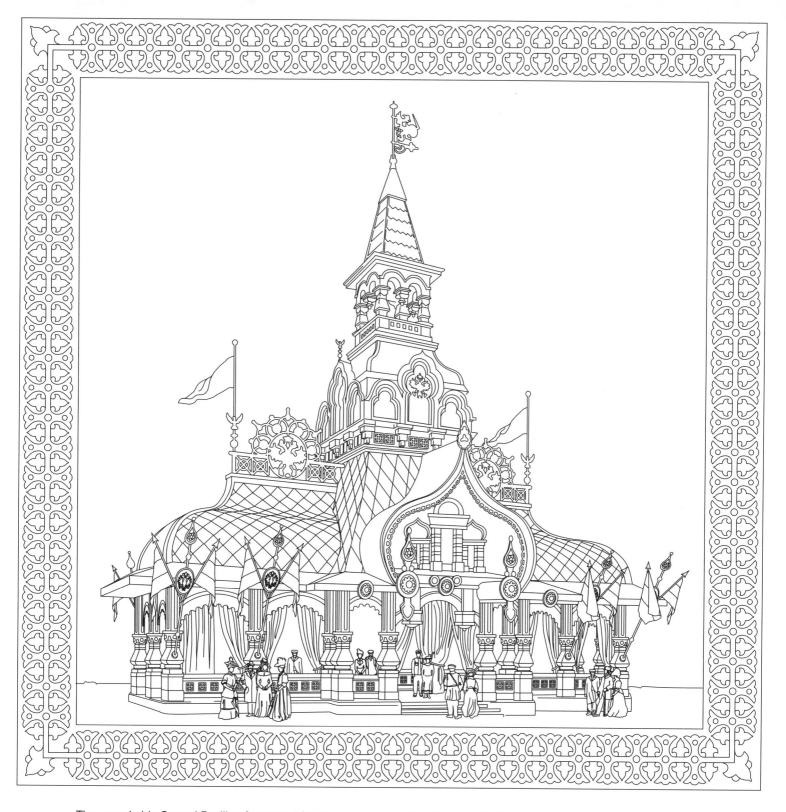

The remarkable Carved Pavilion festooned for the coronation of Tsar Nicholas II. Russian rulers were popularly known as "Tsar" (a title adapted from "Caesar"), although formally known as "Emperor," which signified they ruled over multiple lands.

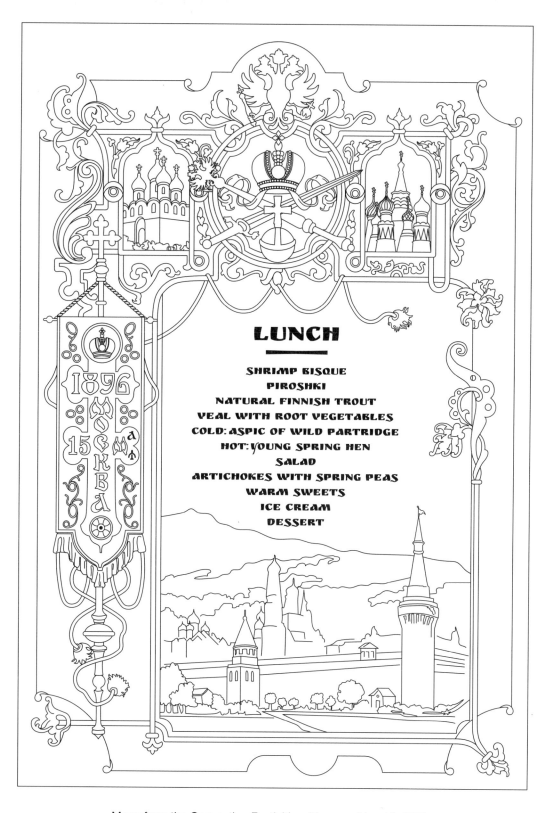

# LUNCH

---

SHRIMP BISQUE
PIROSHKI
NATURAL FINNISH TROUT
VEAL WITH ROOT VEGETABLES
COLD: ASPIC OF WILD PARTRIDGE
HOT: YOUNG SPRING HEN
SALAD
ARTICHOKES WITH SPRING PEAS
WARM SWEETS
ICE CREAM
DESSERT

Menu from the Coronation Festivities, Moscow, May 15, 1896.

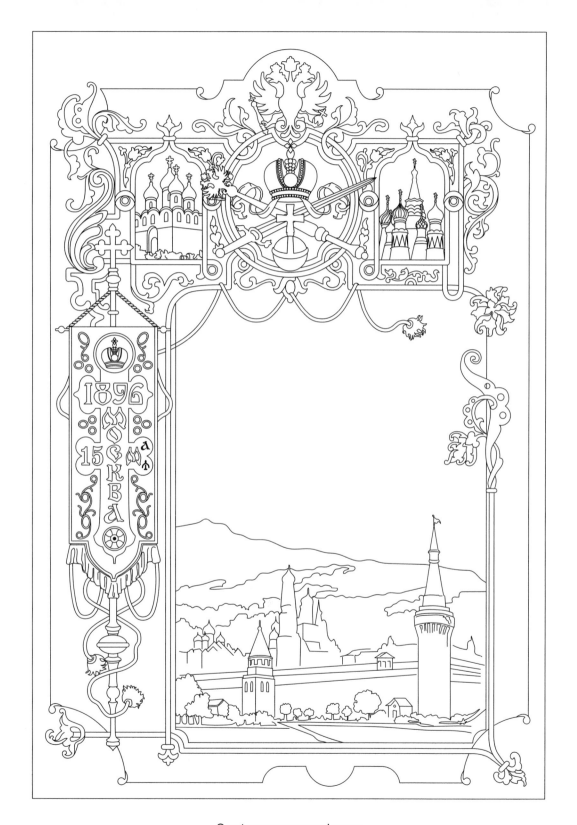

Create your own royal menu.

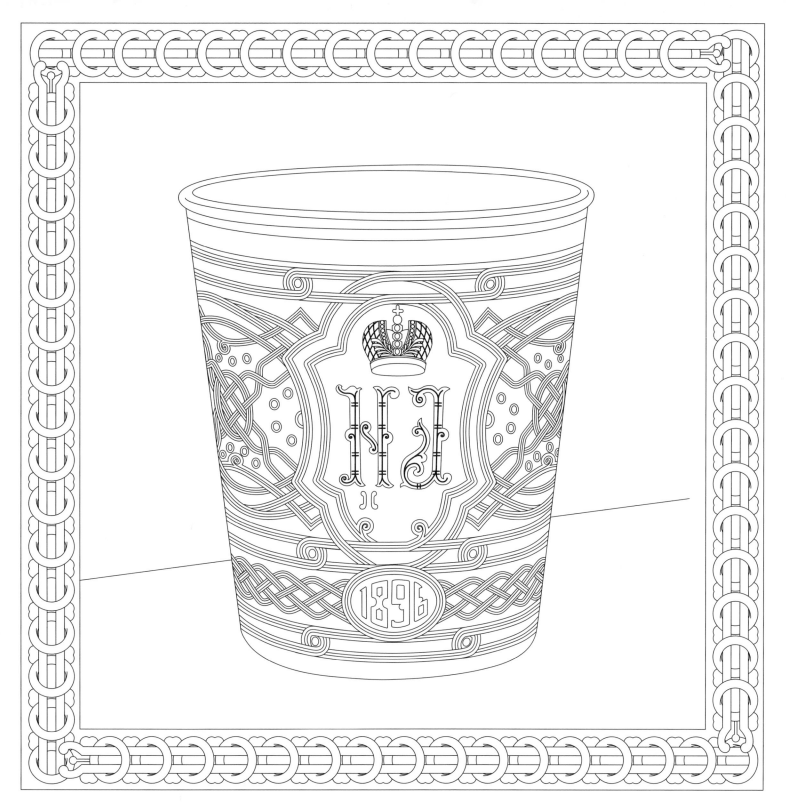

The enamel Coronation Cup was promised as a gift to the people in celebration of Nicholas II's coronation.
However, it has become known as the "Cup of Sorrows."

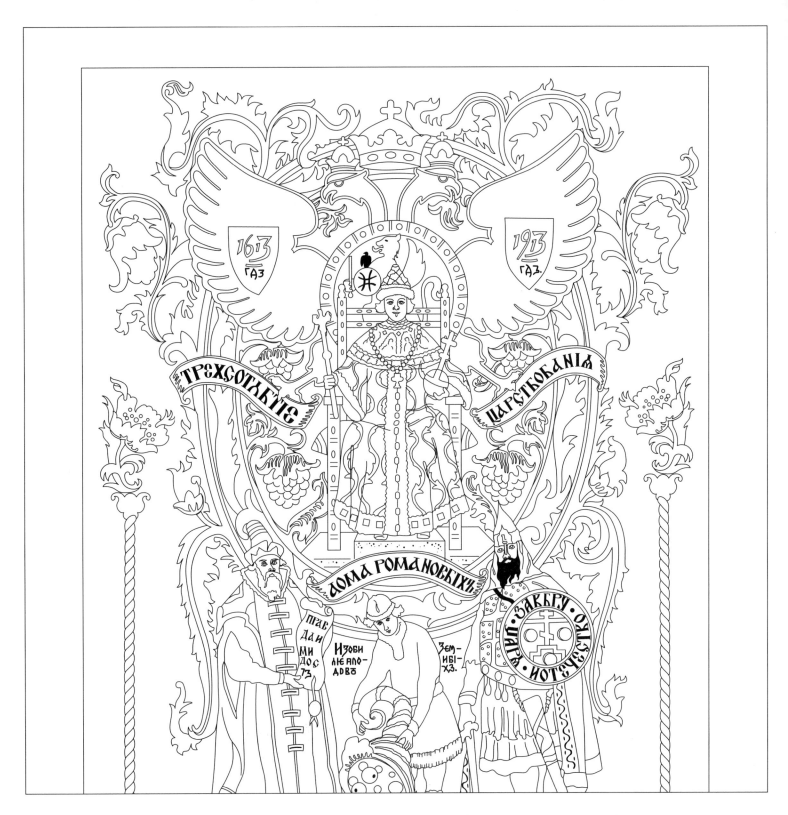

A detail from a menu for a feast marking the celebration of the 300th anniversary of The House of Romanov.

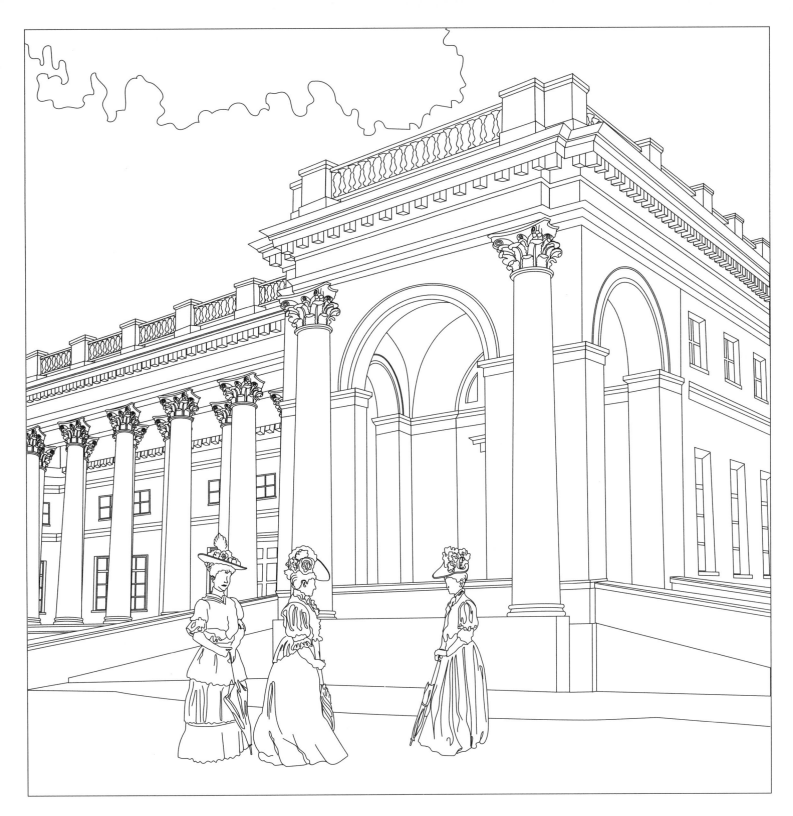

The Alexander Palace, just outside of St Petersburg, was the favorite home of Nicholas & Alexandra.

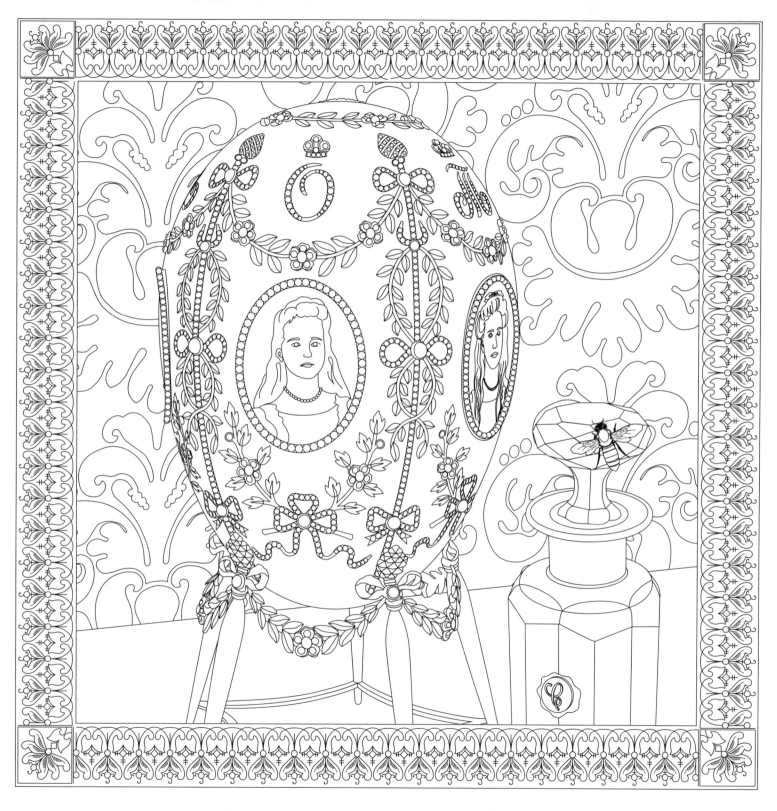

The Alexander Palace Egg, by Fabergé, presented by Nicholas to Alexandra for Easter, 1908.
Hidden inside is a tiny replica of the Alexander Palace.

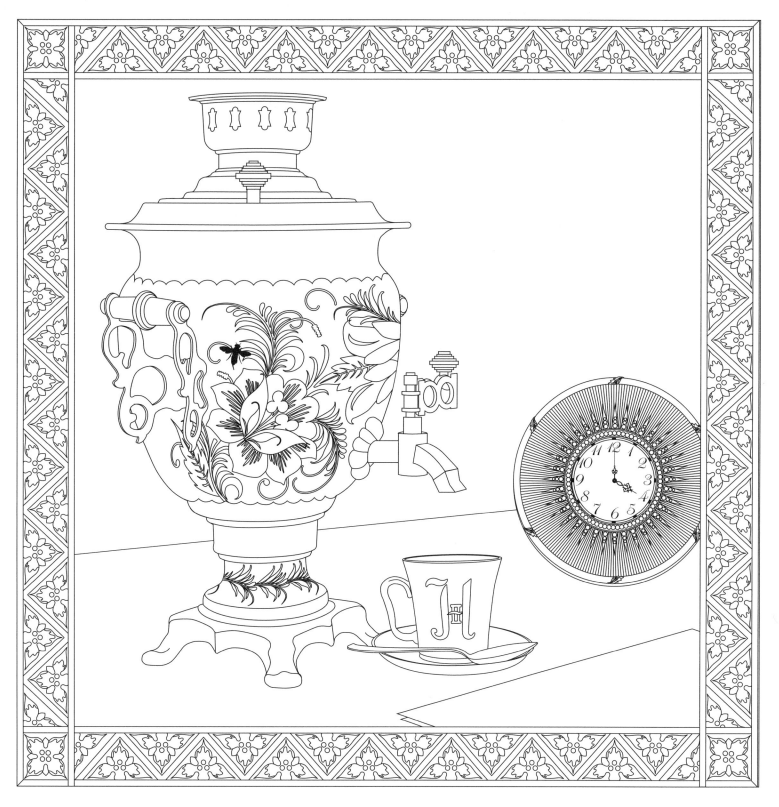

There was nothing that Nicholas loved more than gathering for late afternoon tea with Alexandra and their five children.

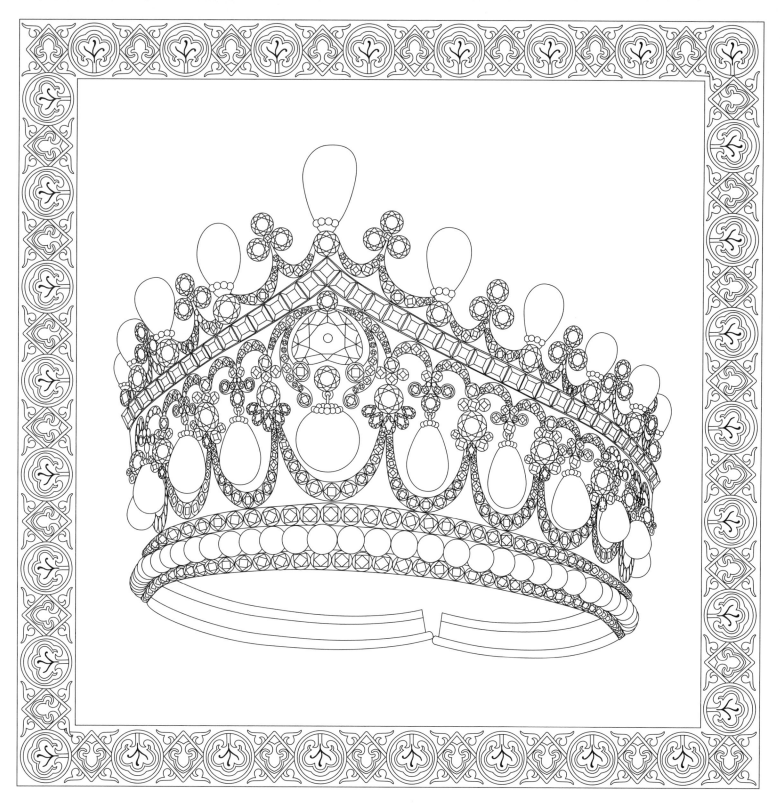

The Diadem of Ancient Pearls and Diamonds was one of Alexandra's favorites. Made by Bolin, Jewelers to the Imperial Court, this piece was made of 340 brilliants from Brazil. It disappeared after the Revolution and its whereabouts are still unknown.

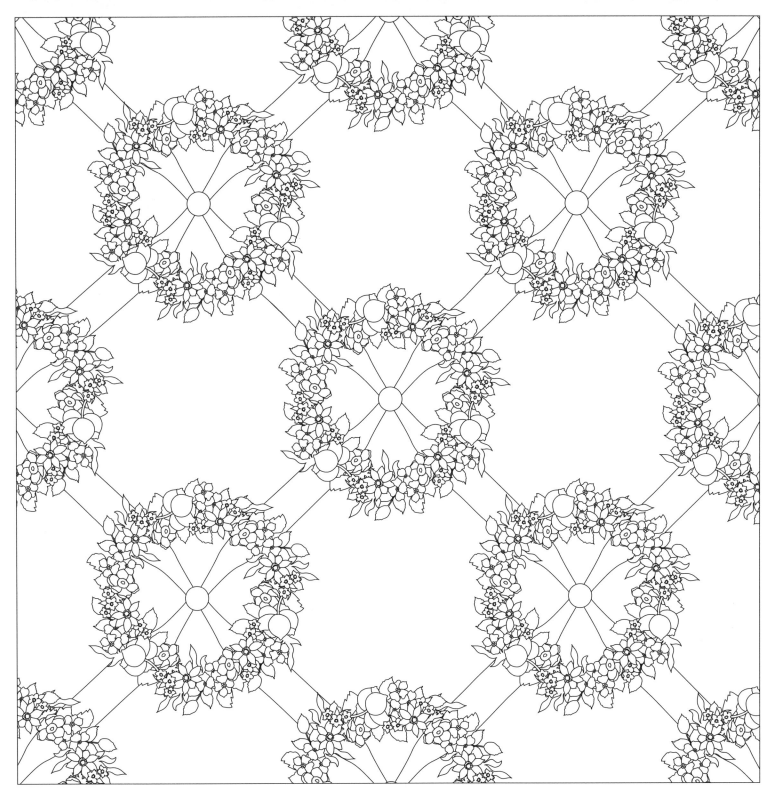

As Queen Victoria's favorite granddaughter, Alexandra grew up speaking English, which was also the primary language she spoke with Nicholas. Alexandra loved all things English, including this chintz wallpaper that decorated the Imperial Bedroom.

A close-up of the chintz print that decorated the walls, curtains, and furniture in the Imperial Bedroom.
Pink ribbons connected floral wreaths as if in a bright English garden.

Lilacs were not only Alexandra's favorite flower, but the inspiration for the color of her Mauve Boudoir.

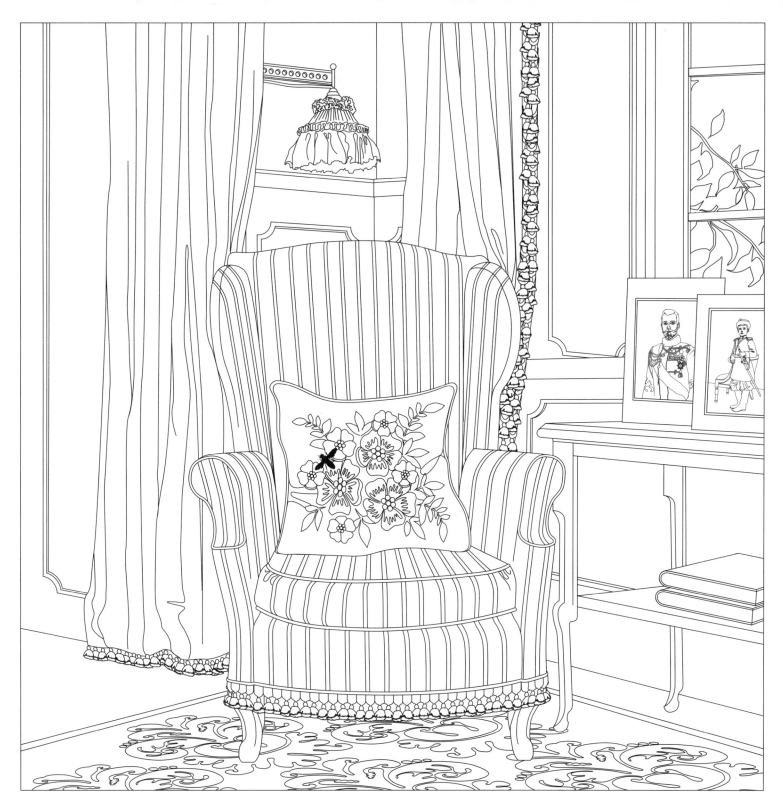

The beloved Corner Chair in Tsarina Alexandra's Mauve Boudoir—over 100 family photos were taken here, most of them featuring the children through the years.

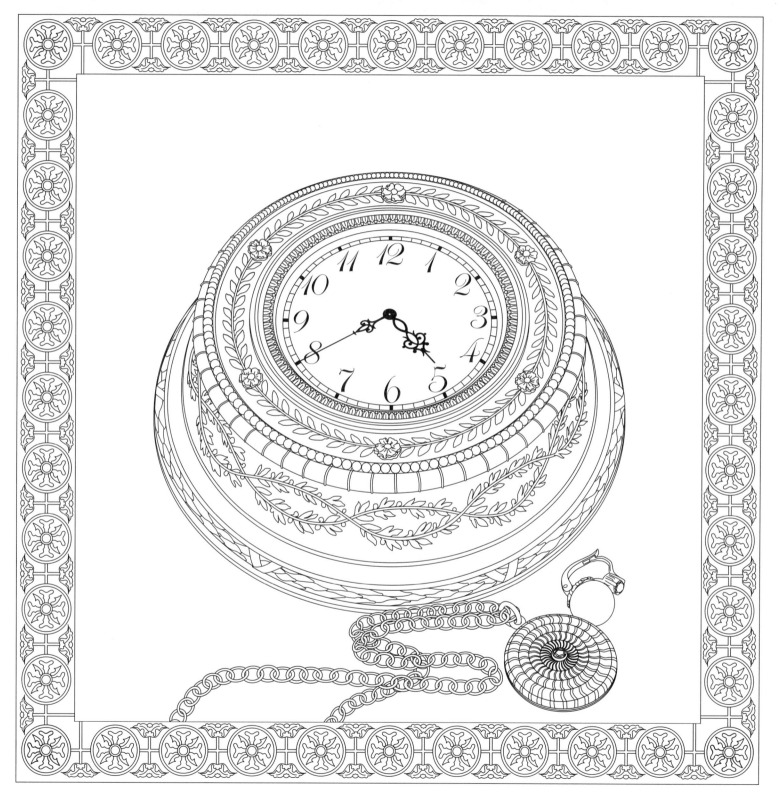

A Fabergé table clock of gold and silver with bands of red and powder blue guilloché; seed pearls decorate the bezel.
Alongside, more Fabergé jewelry, including one of the Tsarina's earrings.

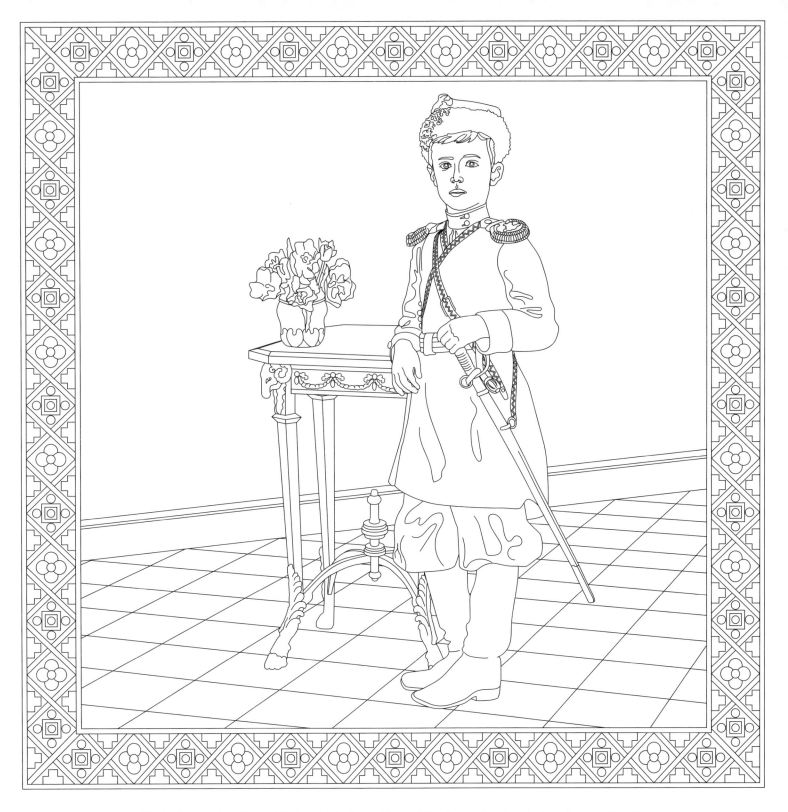

The Heir Tsarevich Alexei Nikolaevich in the uniform of the Jaeger Regiment of the Imperial Family.
Born in 1904, he remains perhaps the world's most famous hemophiliac.

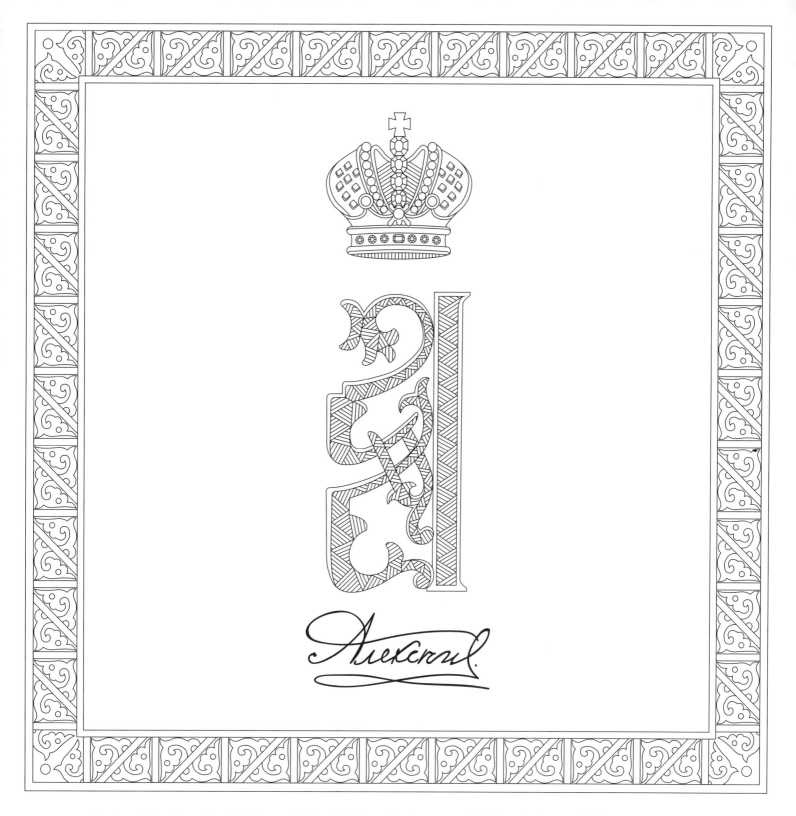

The imperial cypher of the heir, Tsarevich Alexei Nikolaevich, the youngest child and only son of Nicholas & Alexandra.

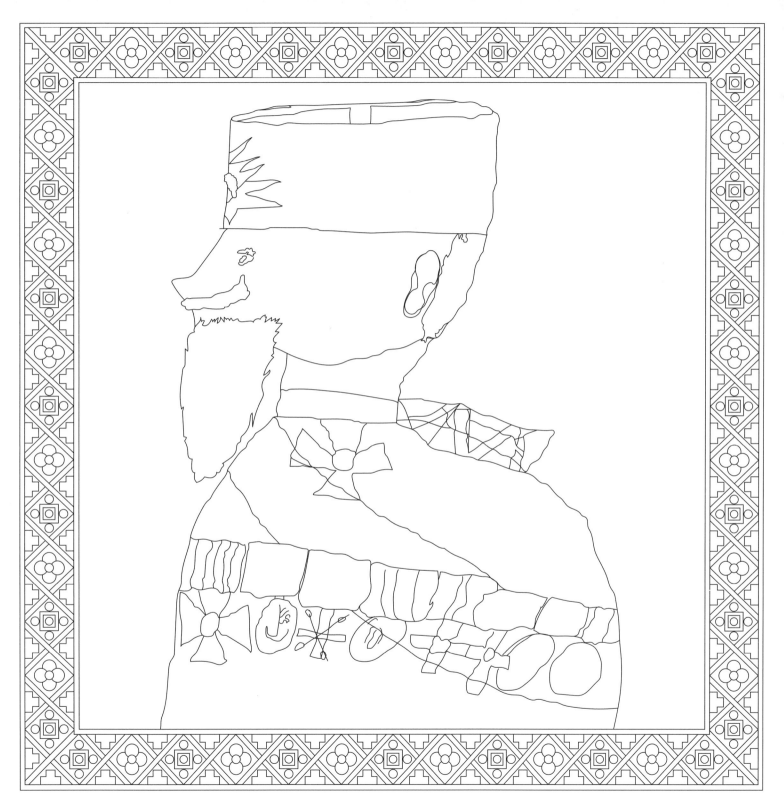

A son's portrait of his father: from a watercolor by Tsarevich Alexei of his father, the Emperor Nicholas II.

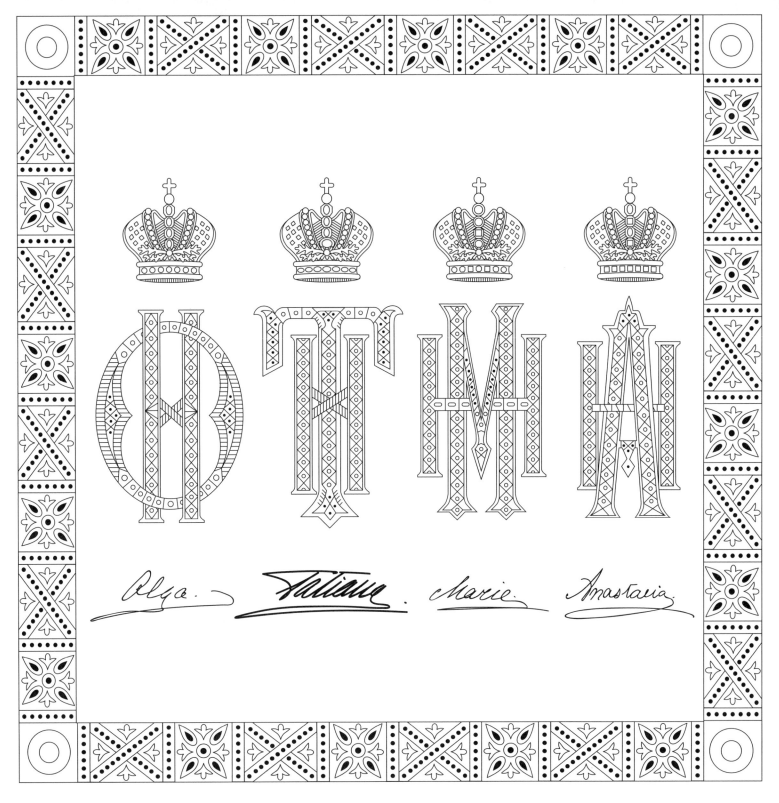

The imperial cyphers of the royal daughters, Olga Nikolaevna, Tatiana Nikolaevna, Maria Nikolaevna & Anastasia Nikolaevna.
They would often jointly sign letters simply: OTMA.

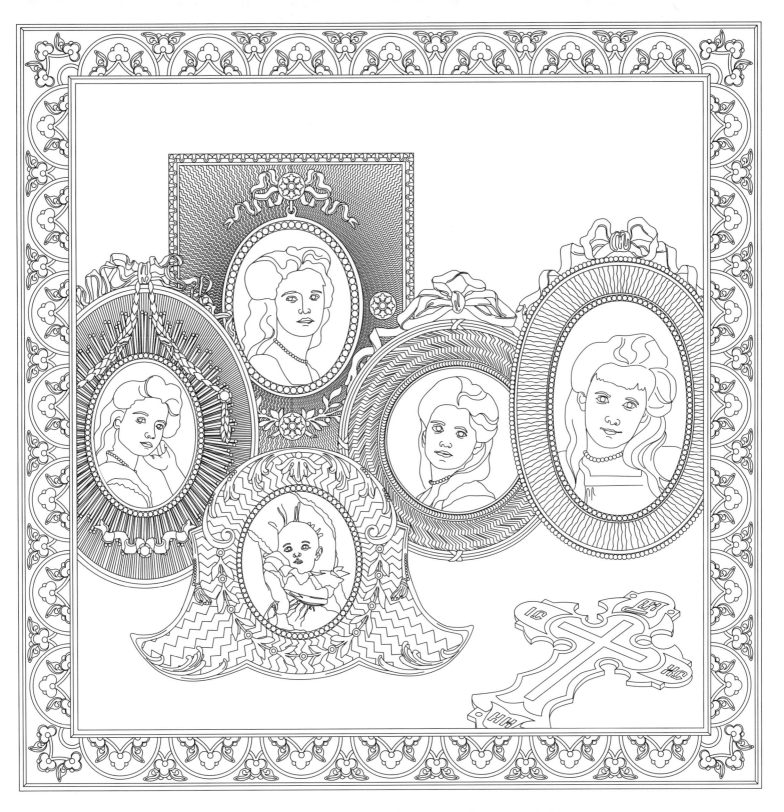

Fabergé's workshop turned out an abundance of bejeweled picture frames, many featuring guilloché, a mechanically engraved pattern coated with colorful enamels. Such frames with photos of the five imperial children could be found in all the imperial palaces.

The oldest of the royal daughters, Grand Duchess Olga Nikolaevna loved to read and paint watercolors.
She later wrote, "It is not evil that conquers evil, but only love."

From a watercolor by Grand Duchess Tatiana Nikolaevna. Many considered her the most beautiful of the four daughters; her sisters called her "The Governess" for her knack to take control.

M. H. 1913.

From a watercolor by Grand Duchess Maria Nikolaevna. The third daughter of Nicholas and Alexandra, she had always hoped to marry and have a large family.

A proud young Grand Duchess Anastasia did this watercolor of herself and gave it to her father.
However, her older sister Olga disliked it, saying, "It looks like a pig riding a donkey."

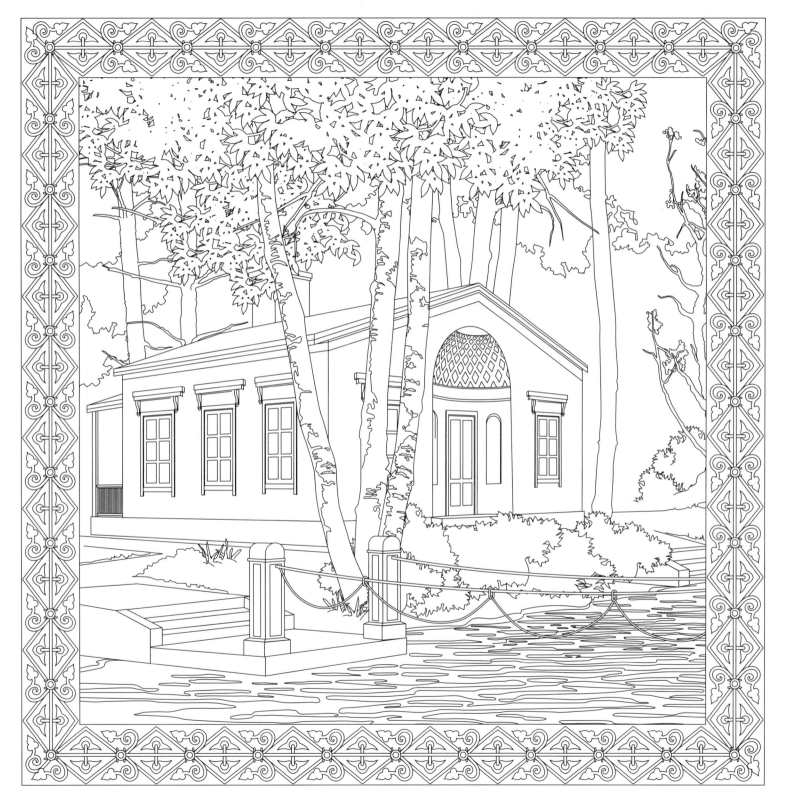

Located on the grounds of the Alexander Palace, The Children's Island and its playhouse were enjoyed by generations of imperial children. It could be reached by pulling oneself across the water on a small ferry.

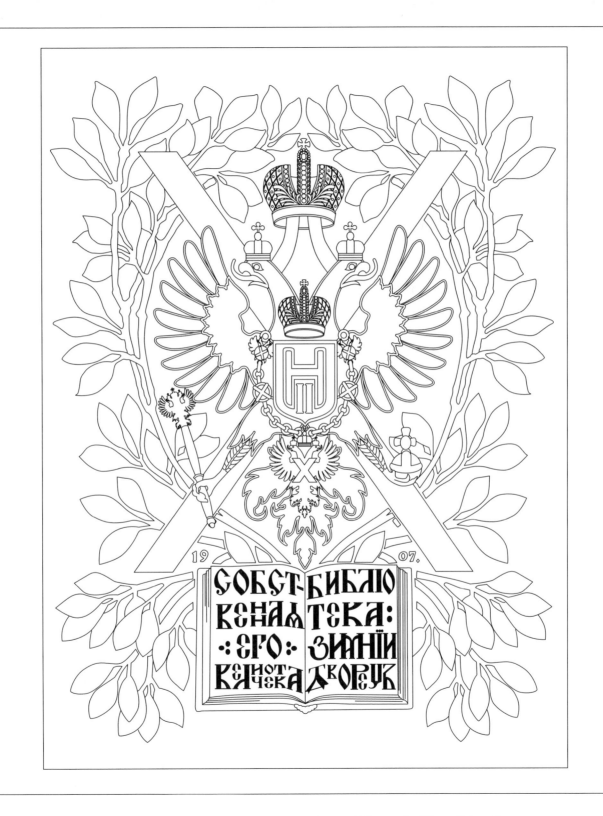

Nicholas II's bookplate: "His Majesty's Personal Library, the Winter Palace."

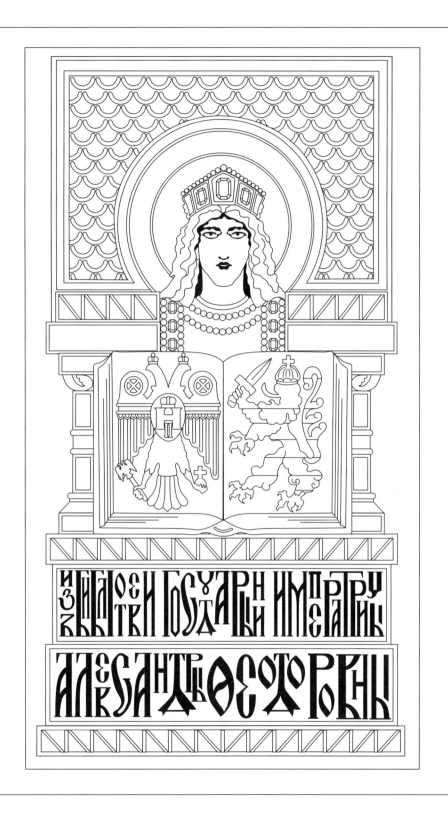

Alexandra's bookplate: "From the Library of Her Imperial Highness Alexandra Feodorovna."

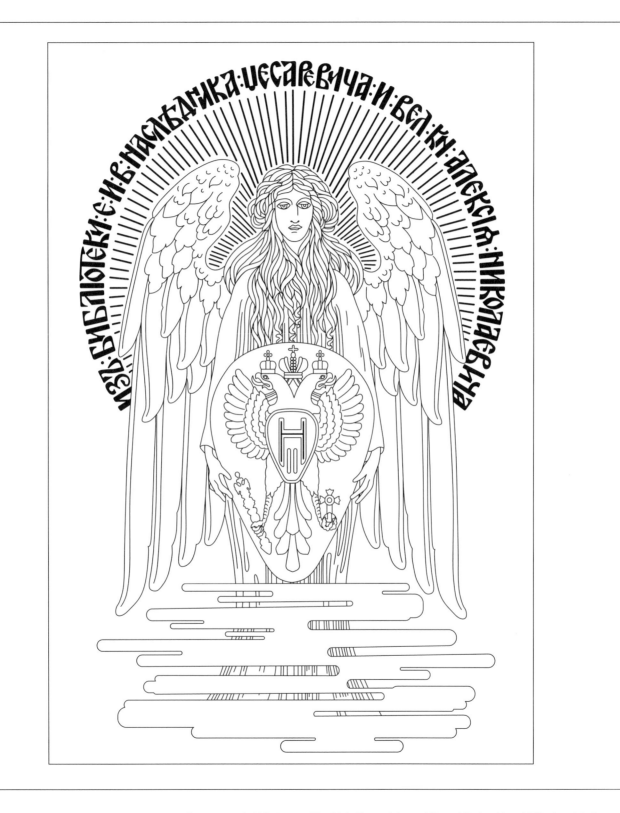

Alexei's bookplate: "From the Library of His Imperial Highness The Heir Tsarevich and Grand Duke Alexei Nikolaevich."

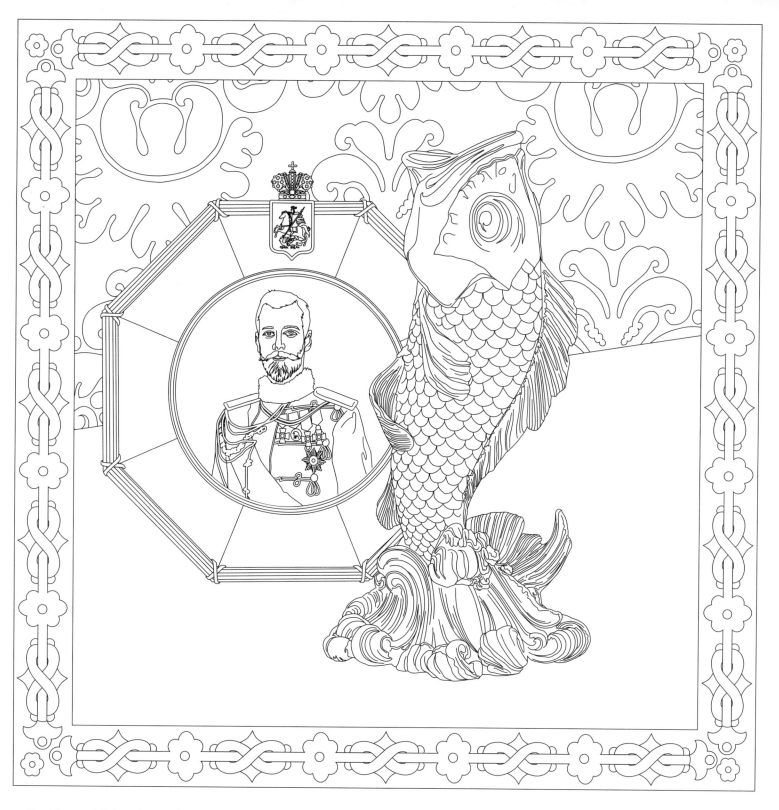

The House of Fabergé was "Goldsmith by special appointment to the Imperial Crown" and employed nearly 500 craftsmen and designers. Their creations included not only the famed Imperial Eggs, but jewelry, vases, walking sticks, picture frames, doorbells, and timepieces.

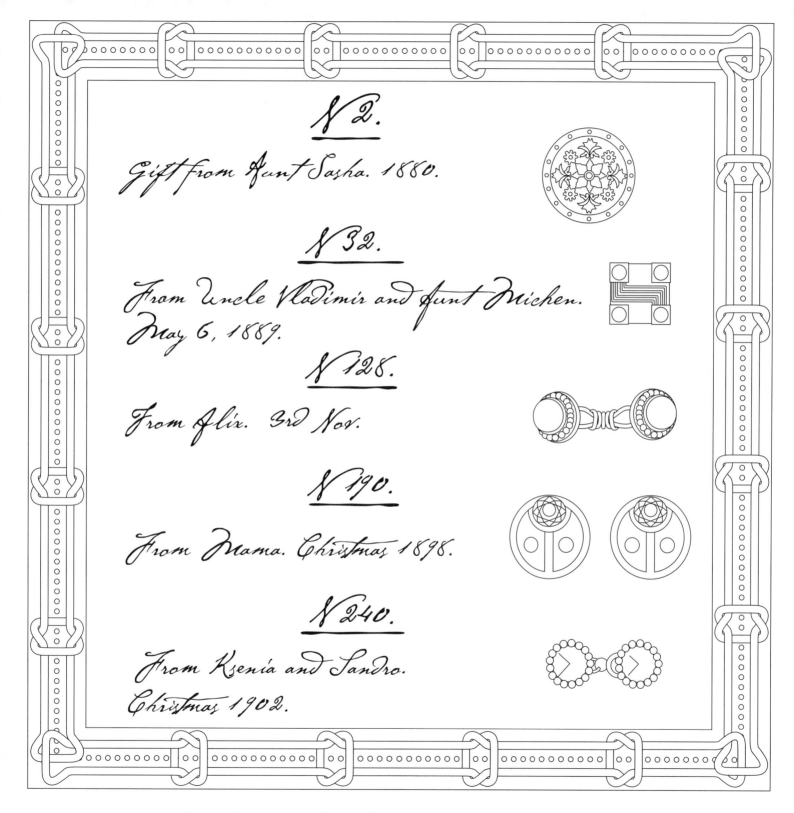

N 2.

Gift from Aunt Sasha. 1880.

N 32.

From Uncle Vladimir and Aunt Michen.
May 6, 1889.

N 128.

From Alix.  3rd Nov.

N 190.

From Mama. Christmas 1898.

N 240.

From Ksenia and Sandro.
Christmas 1902.

Like many Russian royals, Nicholas II kept a record of the jewelry he received as gifts.
He painted each item in watercolor, noting the gift giver, occasion, and date.

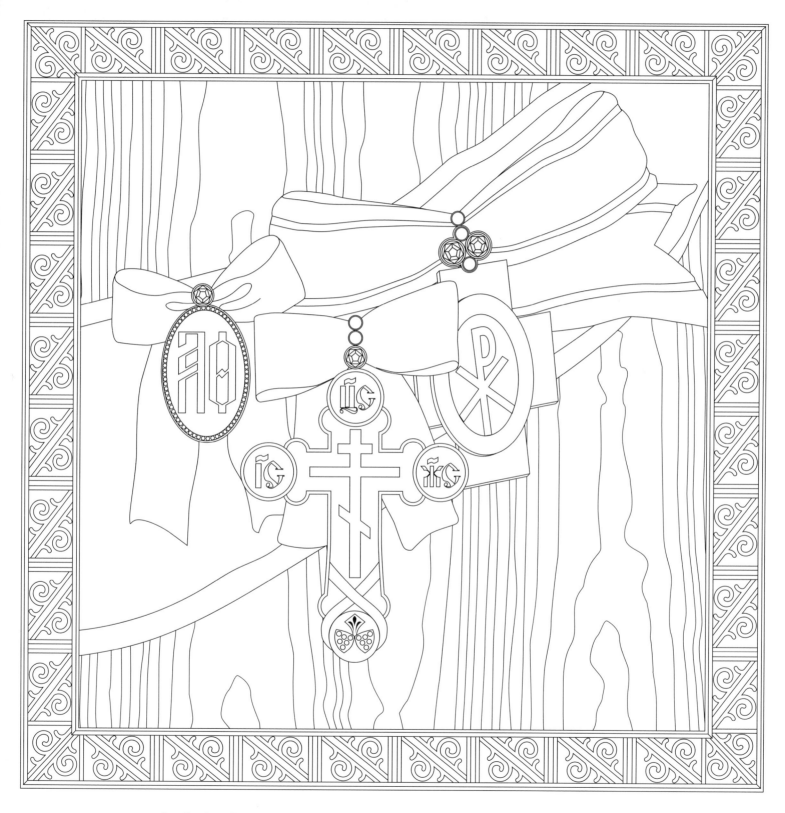

A collection of Alexandra's bejeweled brooches which she would wear on her court dress.

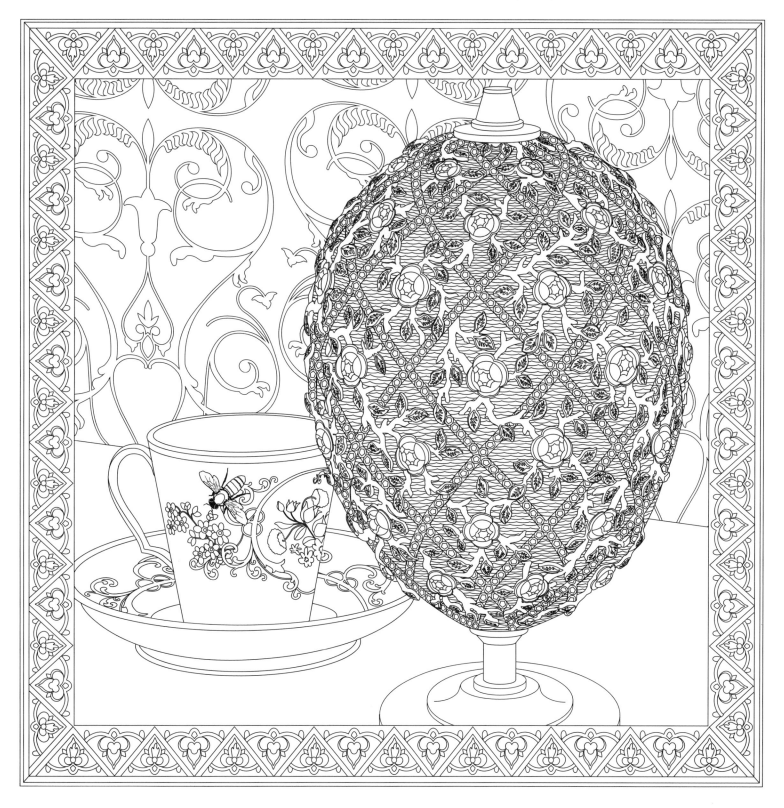

The Rose Trellis Egg, by Fabergé, presented by Nicholas to Alexandra for Easter, 1907.
Crafted of gold, various shades of enamels, and decorated with diamonds.

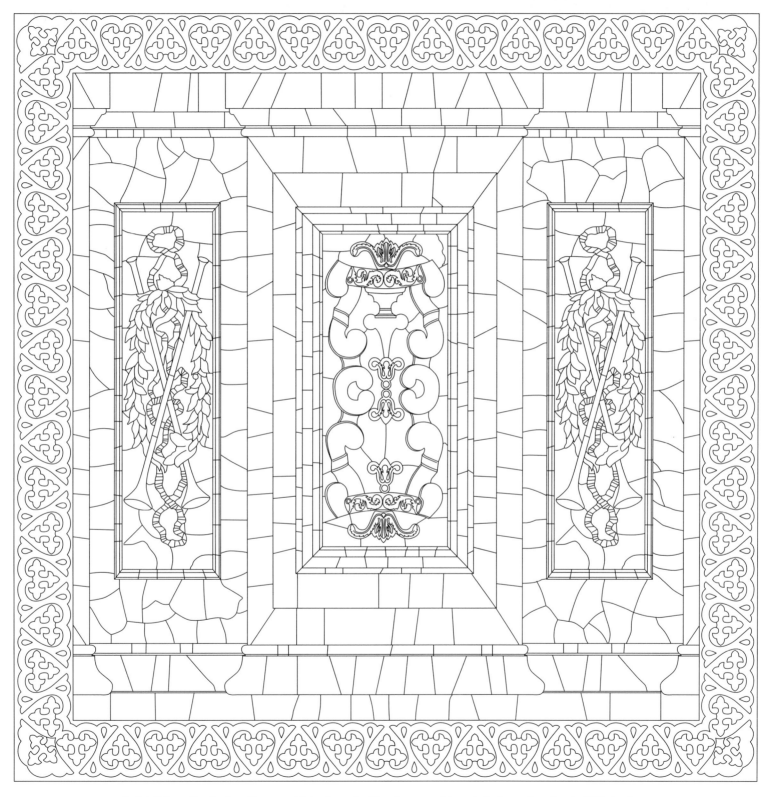

A detail from the Amber Room, which glowed with mirrors, gold, and six tons of amber in 350 shades.
Toward the end of World War II, the entire room vanished without a trace but has since been recreated.

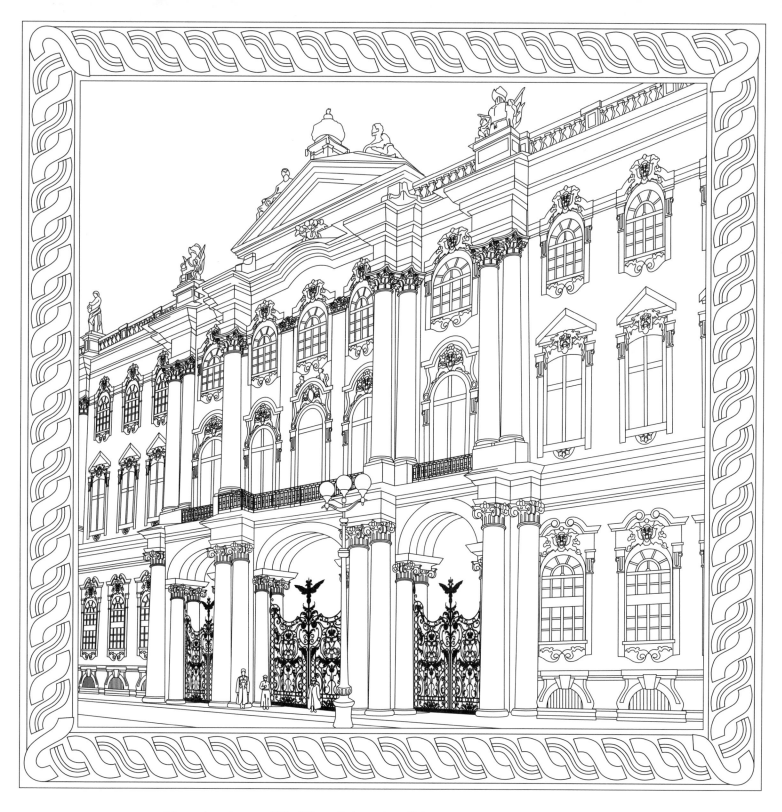

The main entrance of The Winter Palace, the official residence of all Russian monarchs.
Built on a monumental scale, it contains some 1500 rooms.

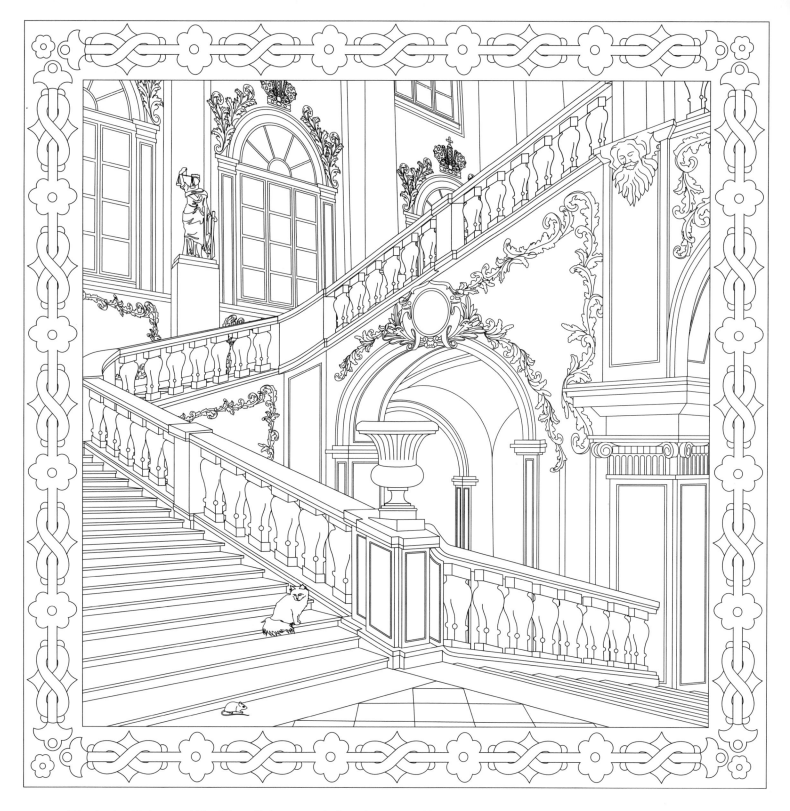

The Jordan Staircase of The Winter Palace was designed to awe and impress with the splendor of the mighty Russian Empire.

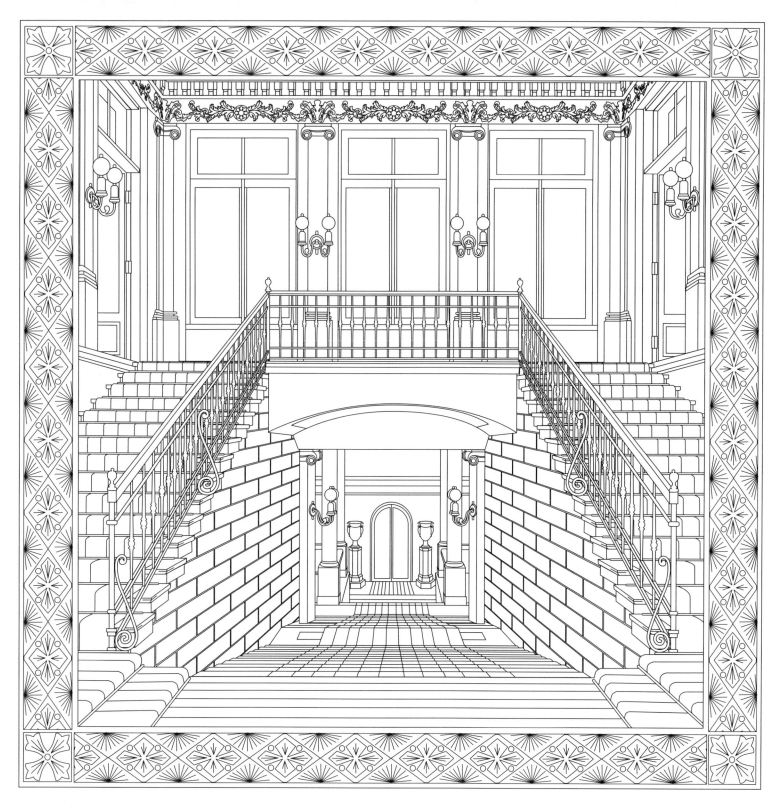

The private apartments of the Romanovs were located on the *piano nobile* (noble, or second floor) of The Winter Palace.
Set apart from the ceremonial rooms of the vast palace, they were reached by staircases reserved for royal use only.

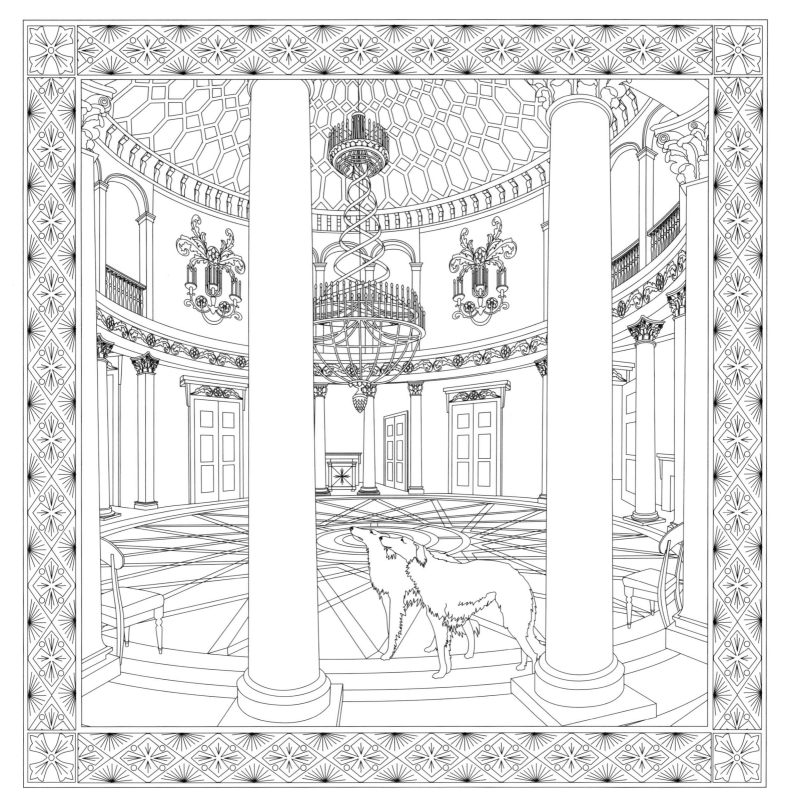

The Rotunda of The Winter Palace, which served as the vestibule to the imperial apartments.

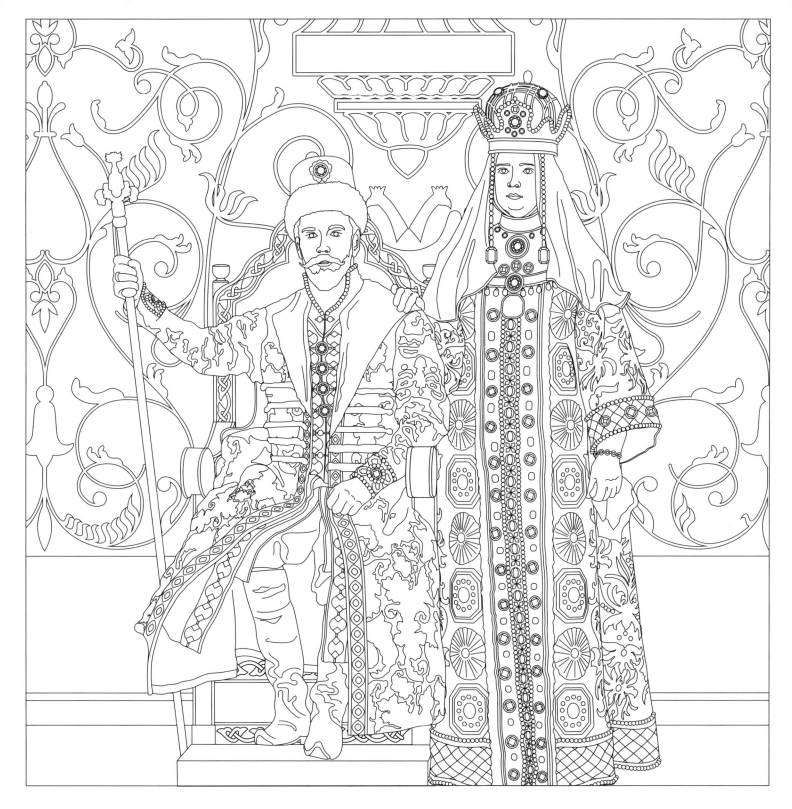

Nicholas and Alexandra in luxurious costume of 17ᵗʰ-century attire for the Costume Ball of 1903.
By all accounts it was the last magnificent ball of the Empire.

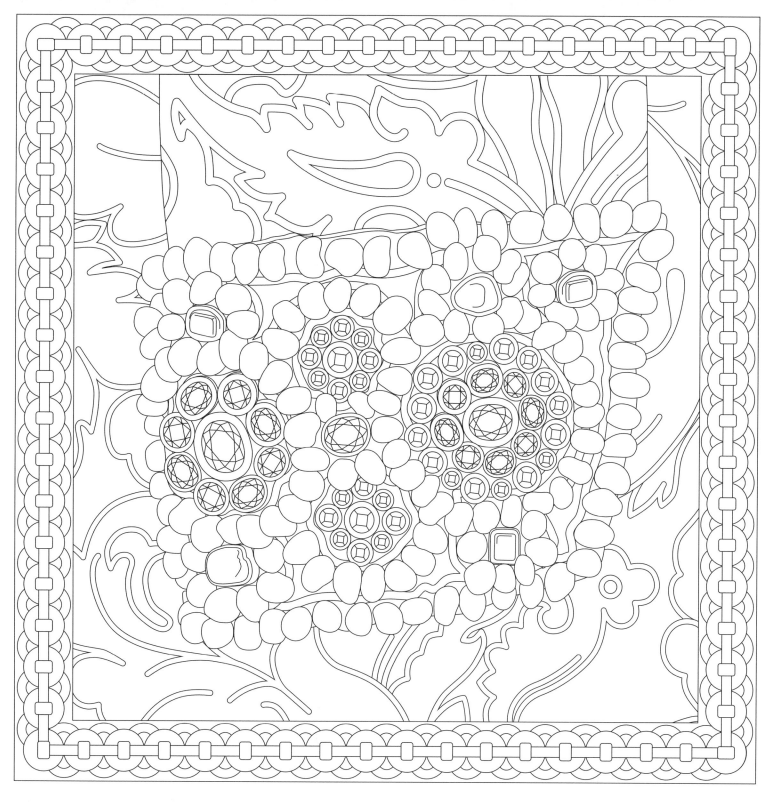

A detail of the 16th-century wristbands sewn onto the robes of Nicholas II's outfit for the Costume Ball of 1903. Two kinds of velvet, gold brocade, gold lace, sable, ancient gems, and 16 pieces of jewelry from the Moscow Armory completed the costume.

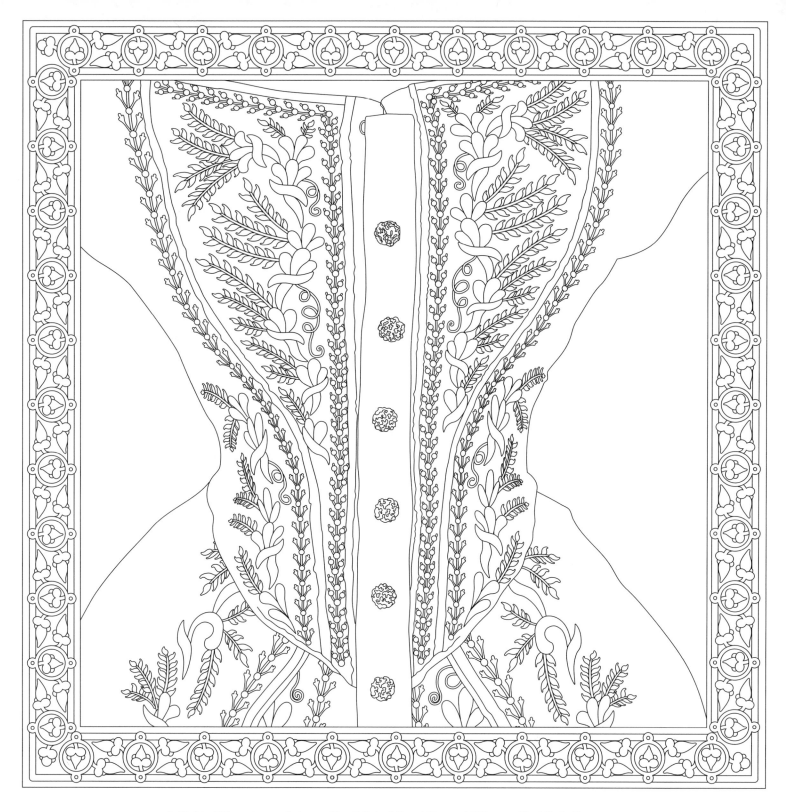

A Maid of Honor's court dress. The Edict of Court Dress, 1833, specified that all women appearing at court should dress in Russian Dress Uniforms of the Muscovite style.

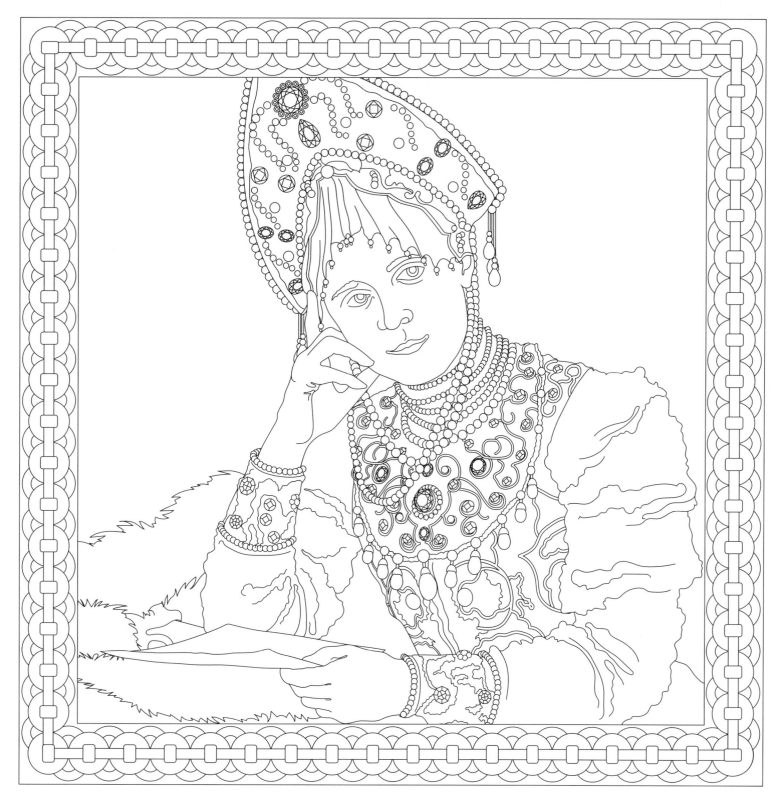

Princess Yusupova, the wealthiest heiress of her day, in 17th-century costume dress for the Costume Ball of 1903.

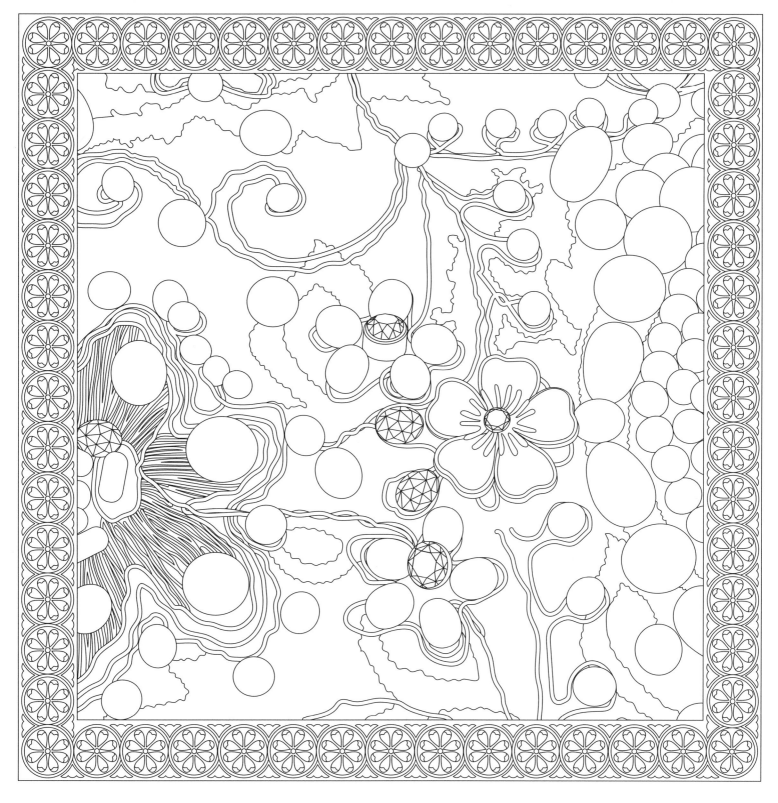

A detail from a Russian princess's kokoshnik, a specific type of Russian headdress, with semiprecious stones and pearls sewn onto a rich silk fabric.

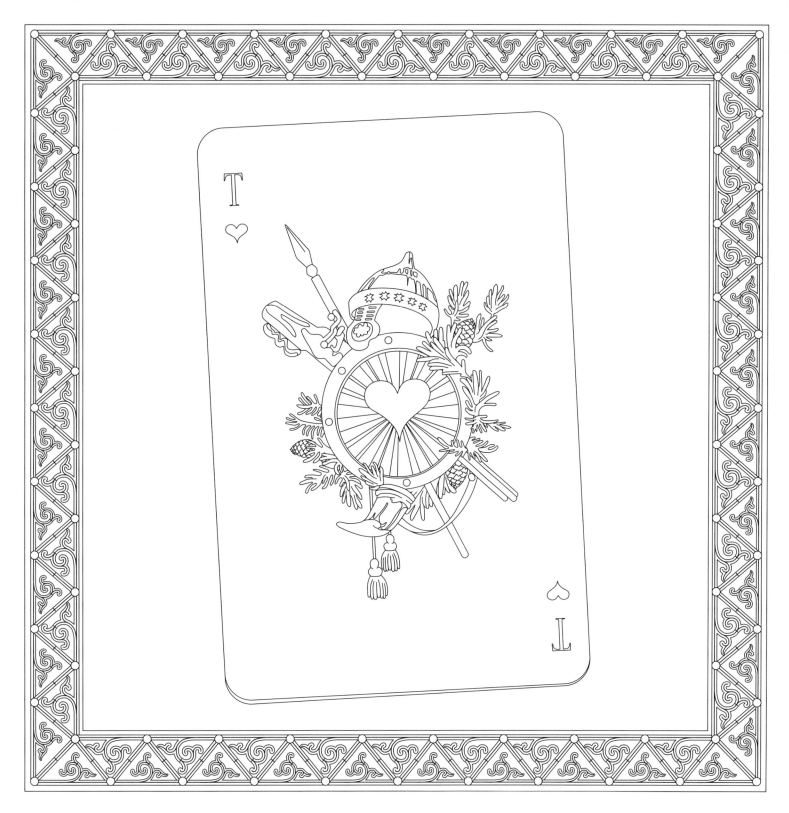

The Ace of Hearts from a deck of playing cards created to commemorate the great Costume Ball of 1903.

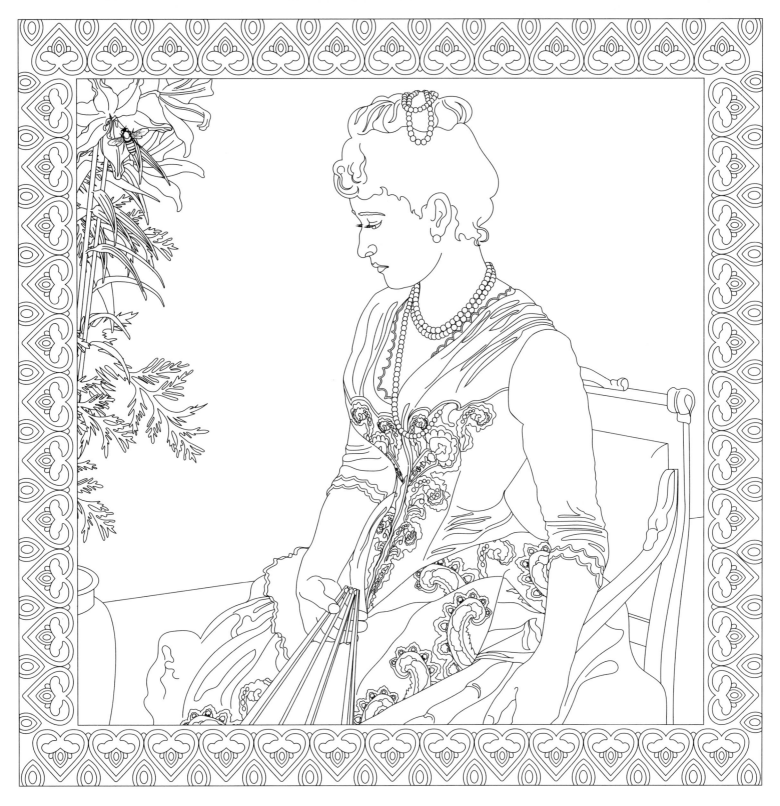

Elizavyeta Fyodorovna, Alexandra's older sister, was widely recognized as one of the two most beautiful princesses in all of Europe. She later sold all her jewels, gowns, and palaces, and became the Mother Superior of her own women's monastery in Moscow.

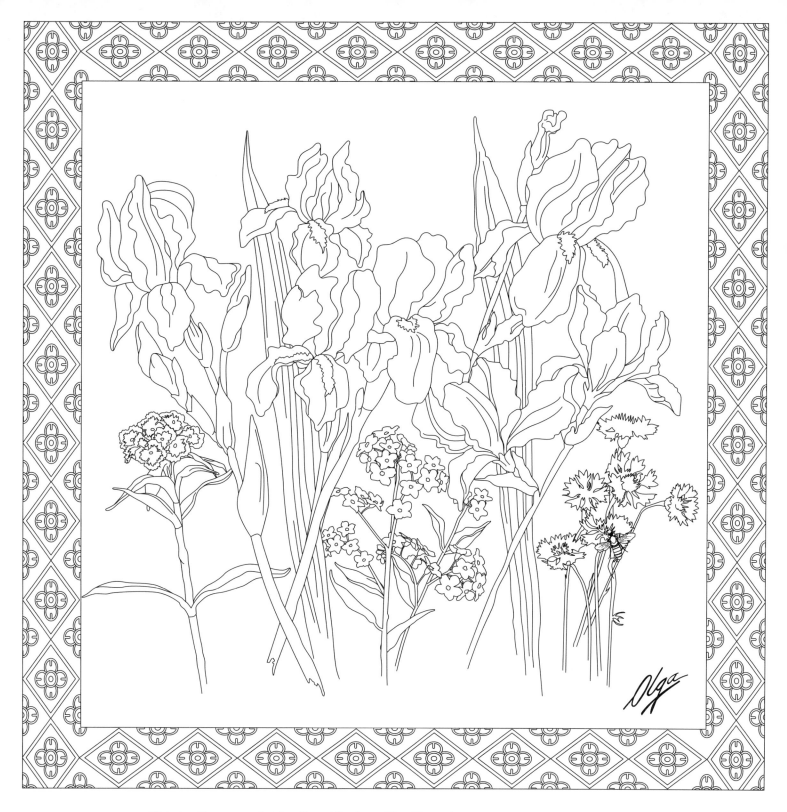

Nicholas II's youngest sister, Grand Duchess Olga Alexandrovna, was an accomplished painter
who focused on the soft light and colors of her beloved Russia.

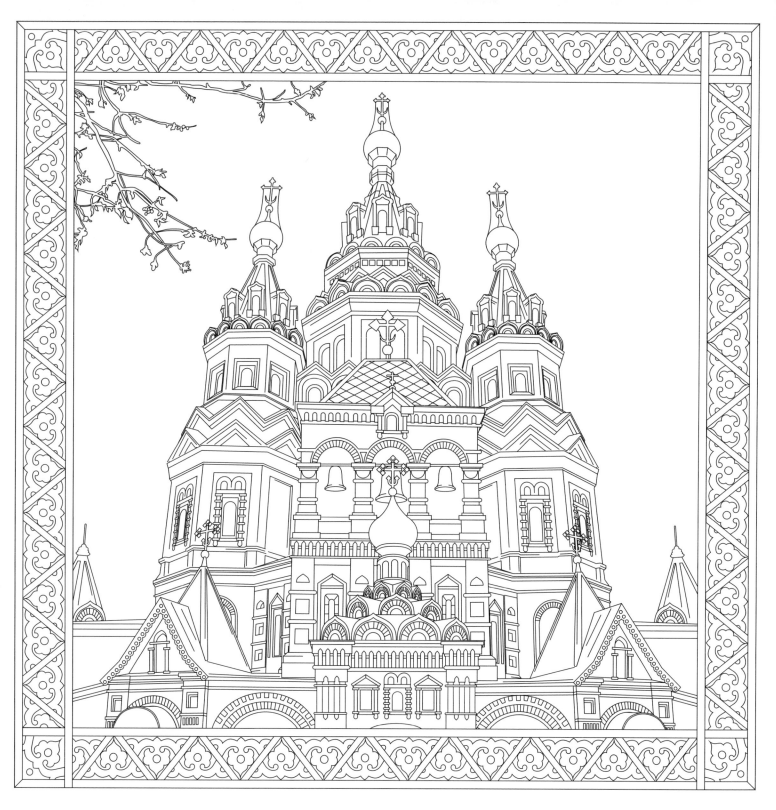

Completed in 1905, the Saints Peter and Paul Cathedral is located in Peterhof, just outside St Petersburg.
It was built in the monumental style of Kievan Rus and decorated with polychrome bricks and red and green roofs.

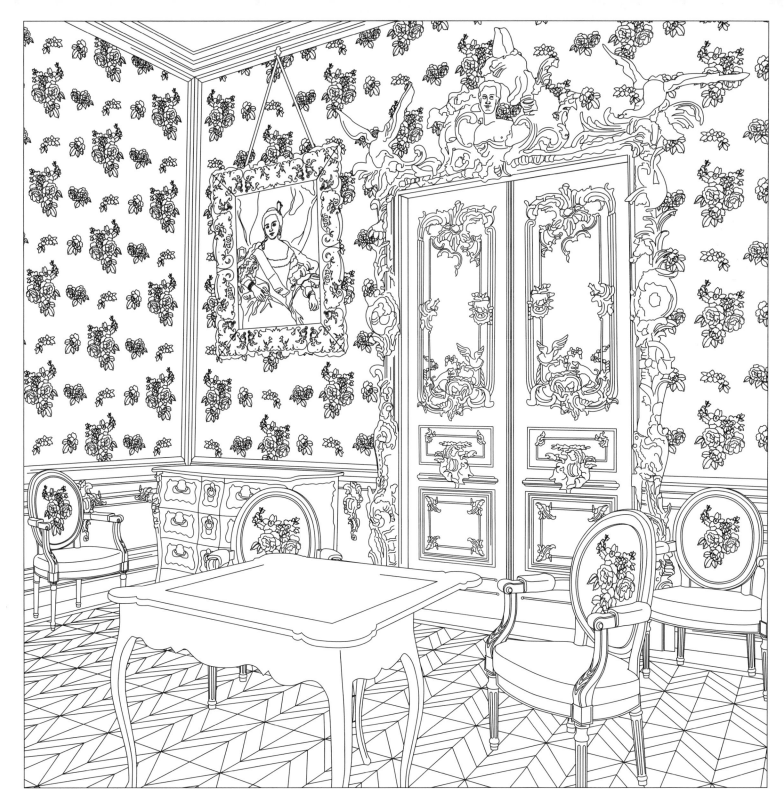

The Sofa Room in the Grand Palace of Peterhof. Peter the Great saw the palace
and its renowned fountains and gardens as his Russian Versailles.

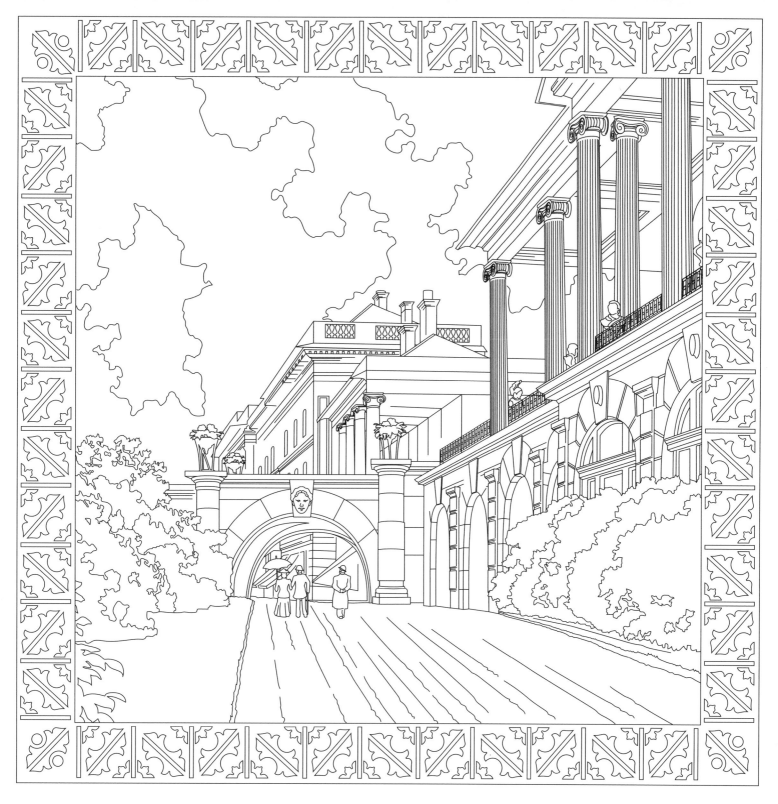

The Cameron Gallery adjacent to the Catherine Palace. Catherine the Great instructed her architect, Charles Cameron of Scotland, to construct this colonnade for strolling and intellectual discussion.

The Singer Building, located on St Petersburg's fashionable and busy main shopping avenue, Nevsky Prospekt.

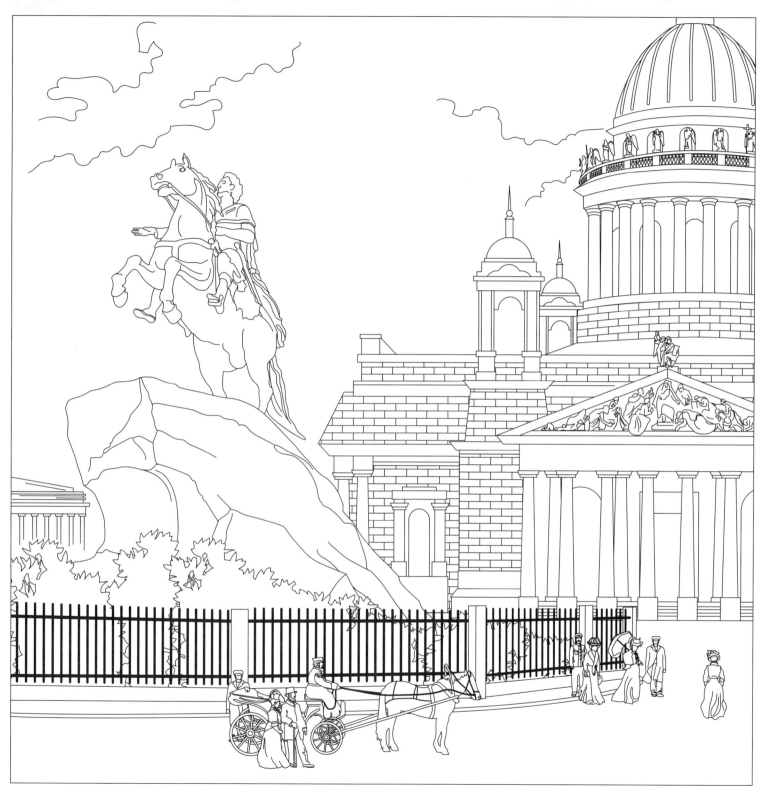

St Isaac's Cathedral is the largest cathedral in St Petersburg and the fourth-largest in the world.
In front of it stands *The Bronze Horseman*, which depicts Peter the Great on horseback.

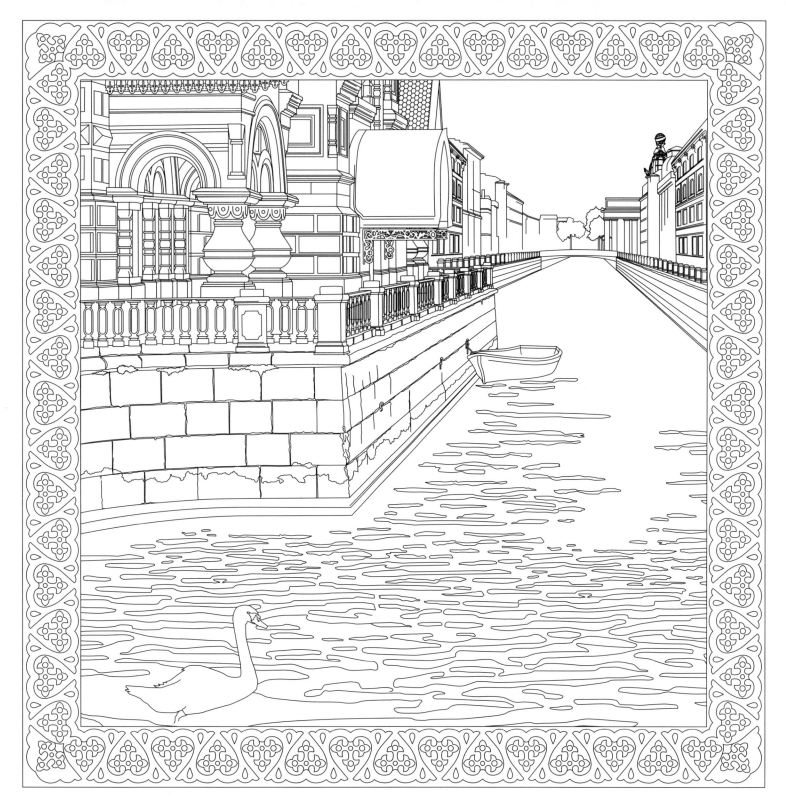

St Petersburg, the imperial capital of the Romanovs, is often referred to as the Venice of the North.
Originally built on more than 100 islands, the city covers a lacework of canals, rivers, creeks, and gulfs.

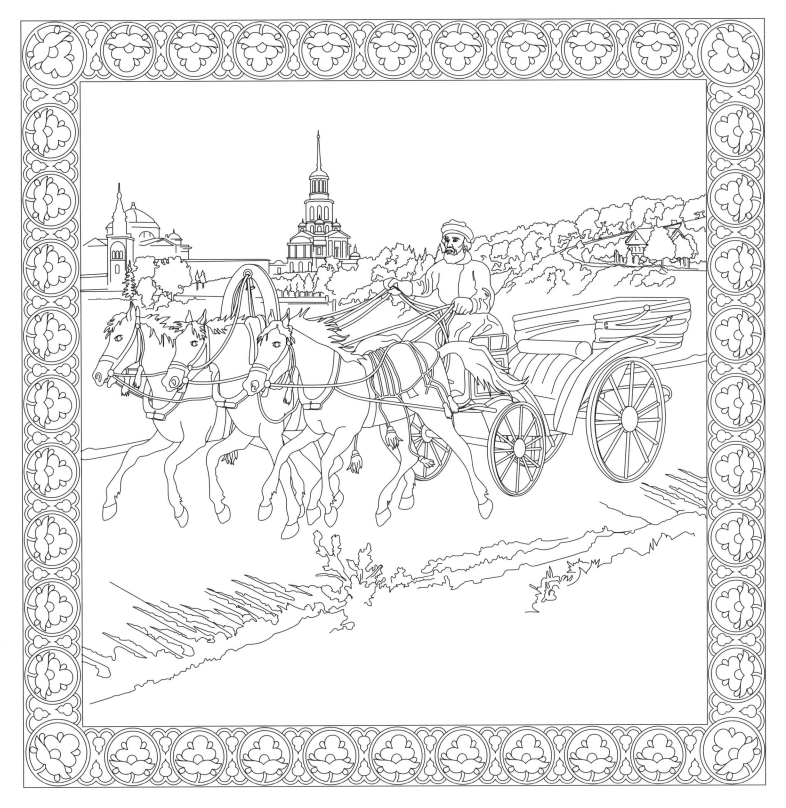

The Russian troika, with three horses harnessed abreast, was developed for unusually speedy delivery of goods.

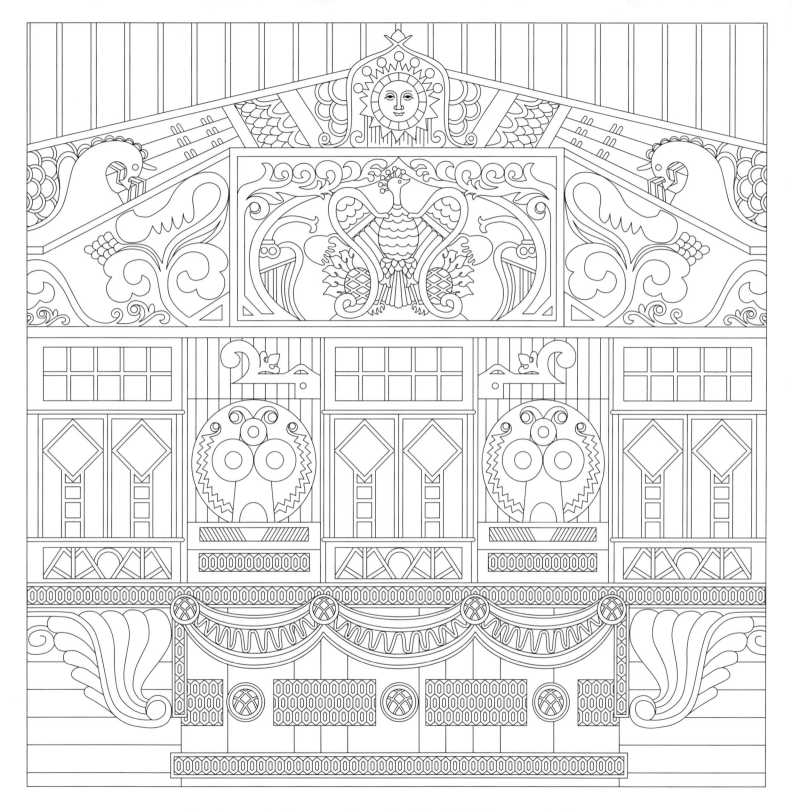

Russians usually disappear on the weekends to their dachas, or country homes.
Often their facades are decorated in a riot of multicolored woodwork.

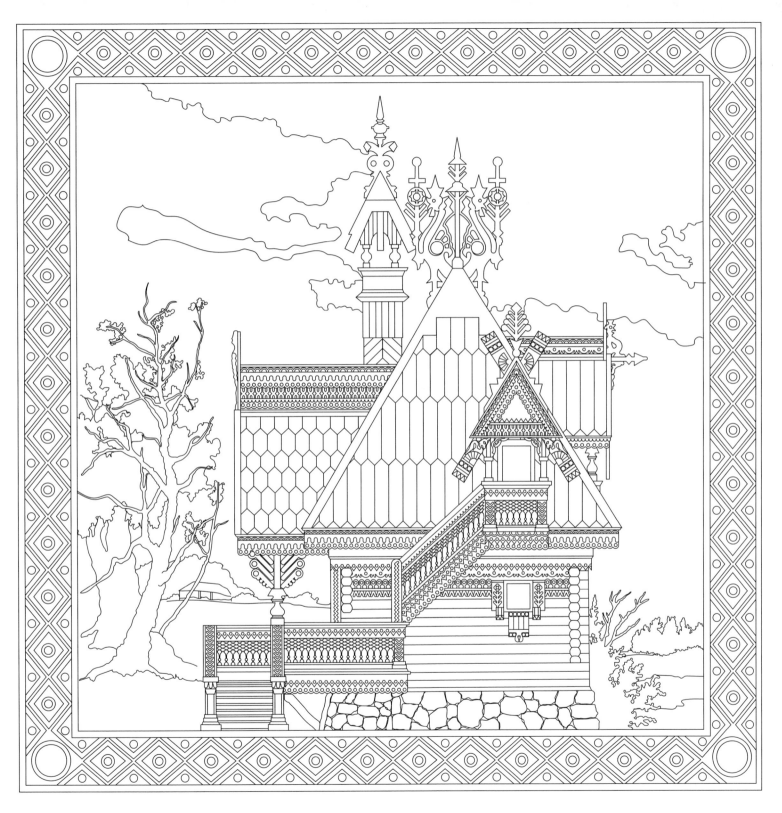

The banya, a Russian type of sauna, is near and dear to the Russian soul and evokes more simple times.
They were often built in plain log huts or more elaborate structures.

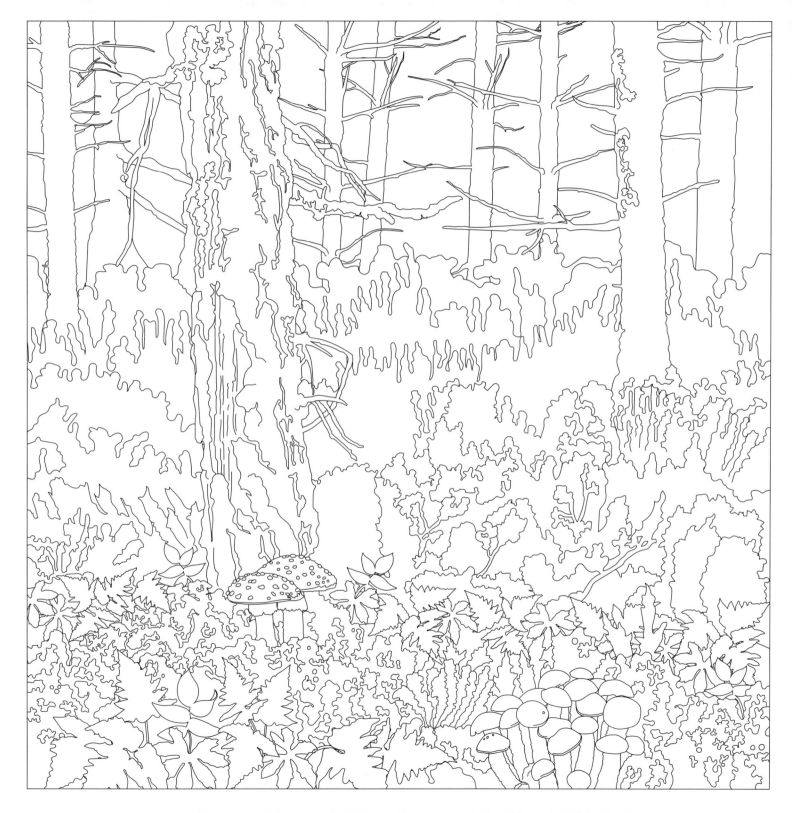

Because Western medicine was not widely practiced or accepted until the early 1800s, Russians
have had a long and profound respect for folk and herbal remedies found deep in their forests.

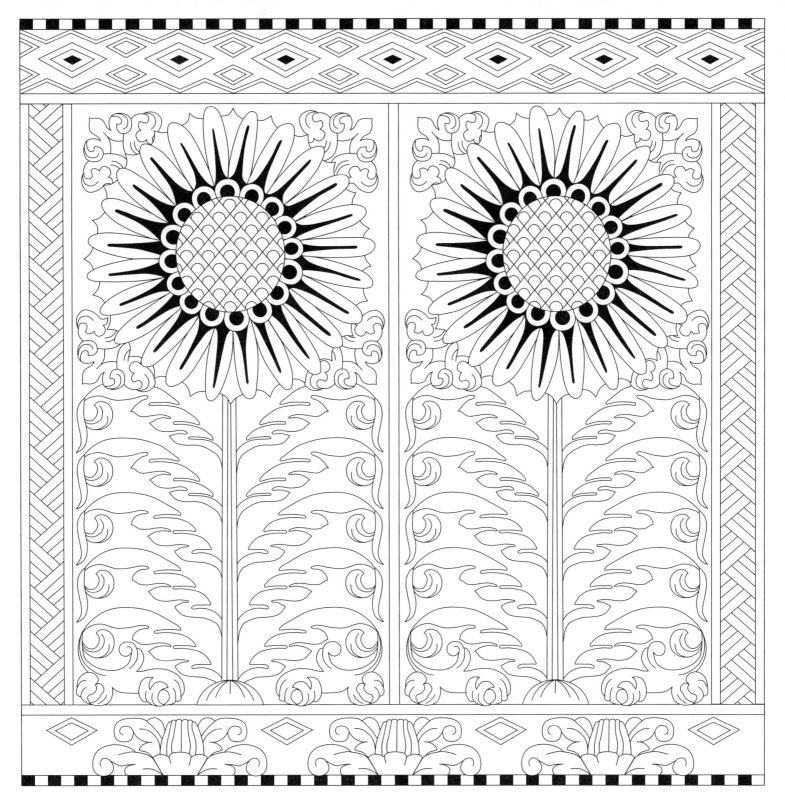

Centuries ago, the simple sunflower was discovered in America, imported to Europe, and then brought to Russia.
In the 19th century, Russian scientists created a new variety, which was brought to the United States as an oil crop.

Originally merely a system of messengers, a more uniform Imperial Postal system was set up by Peter the Great. By 1900 the system was issuing stamps, delivering packages, and overseeing the country's telegraph system.

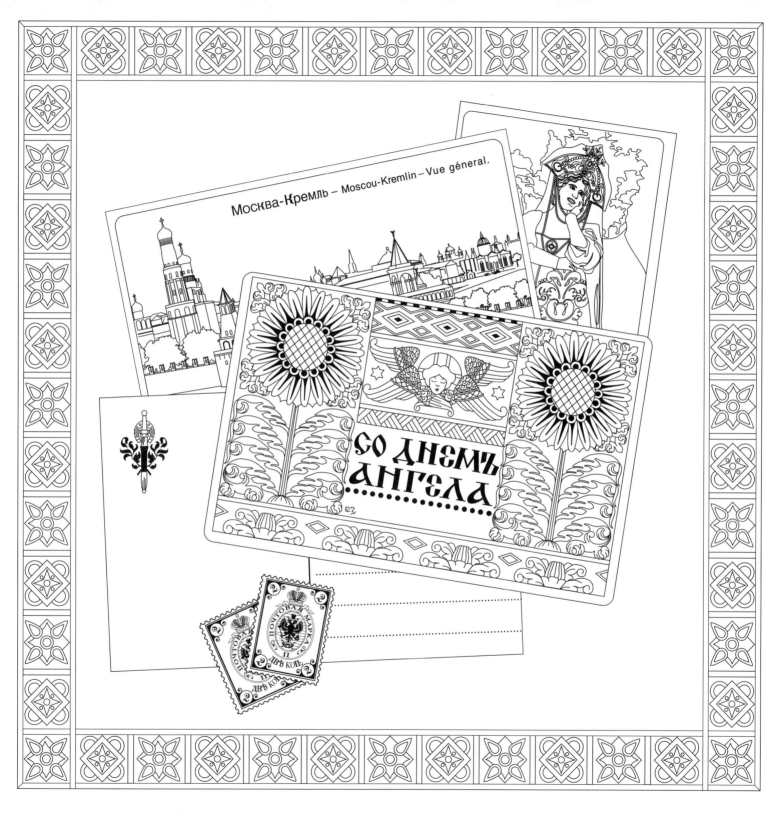

Москва-Кремль – Moscou-Kremlin – Vue géneral.

СО ДНЕМЪ АНГЕЛА

Postcards were a quick and easy way of communication, including cards wishing
"Happy Angel's Day"—for the Saint's Day on which you were born.

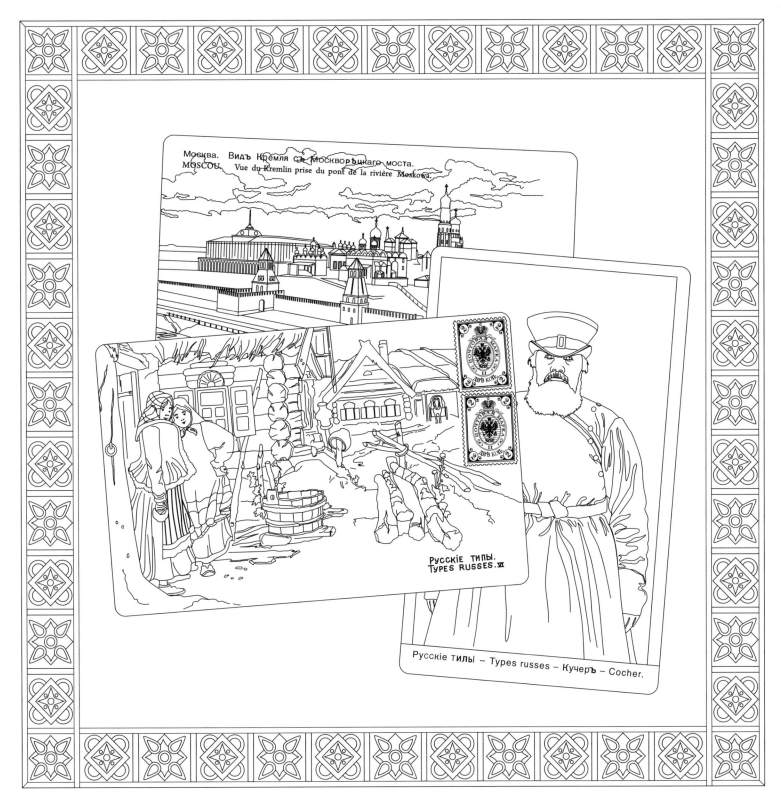

Москва. Видъ Кремля съ Москворѣцкаго моста.
MOSCOU. Vue du Kremlin prise du pont de la rivière Moskowa.

Русскіе типы.
TYPES RUSSES. VI

Русскіе типы — Types russes — Кучеръ — Cocher.

The peasantry made up 80% of Russia's population and lived in scattered villages far from St Petersburg, the capital, and Moscow.

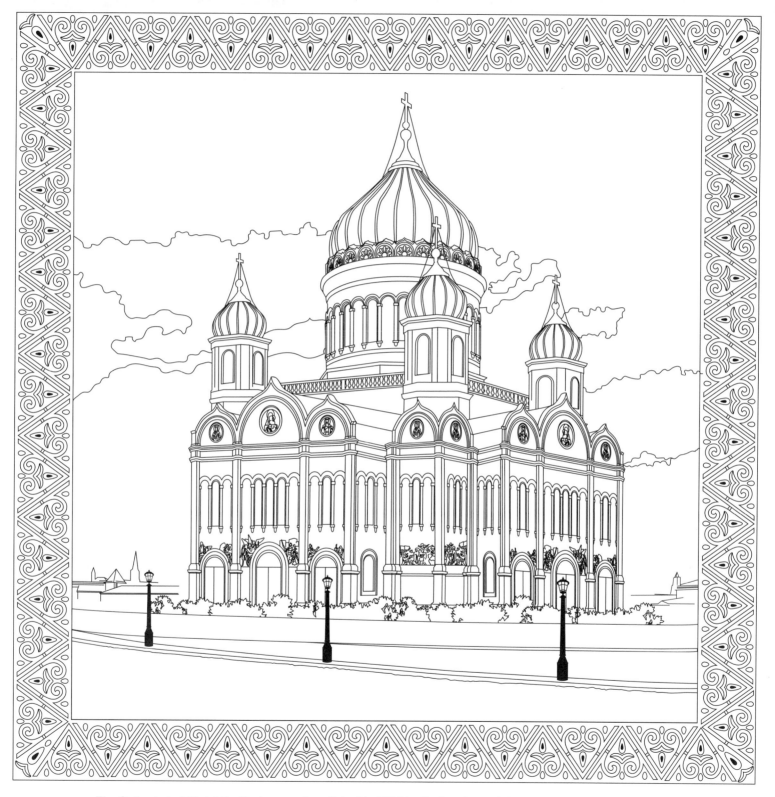

The Cathedral of Christ the Savior was demolished in 1931 by Stalin, who took 20 tons of gold from its domes.
Khruschev later transformed the foundation into the largest open air pool in the world. It has recently been precisely rebuilt.

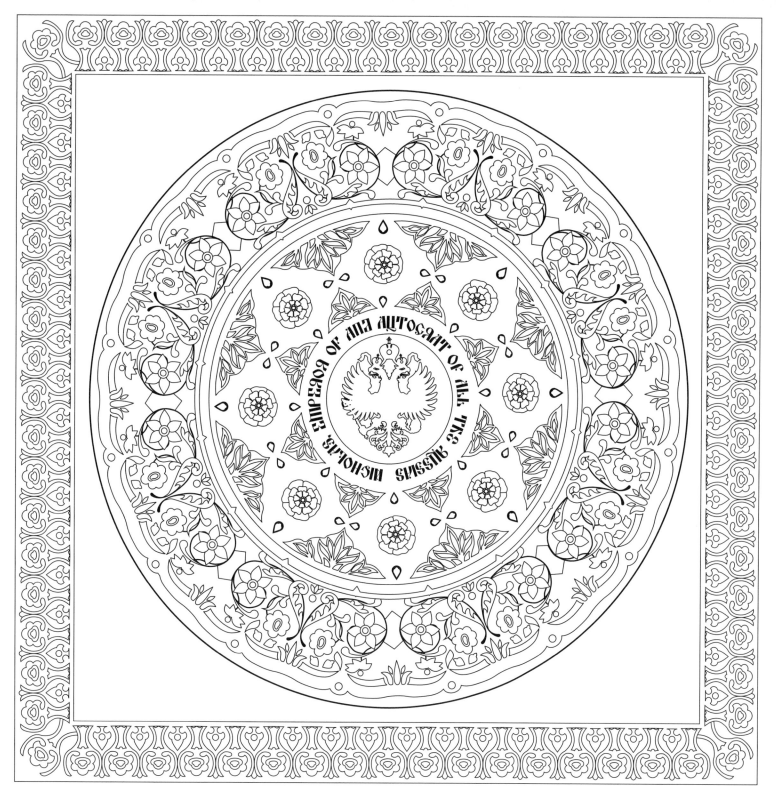

Part of the dessert service of the magnificent Kremlin Service. Porcelain from the Imperial Porcelain Manufactor was so valued it was referred to as "white gold."

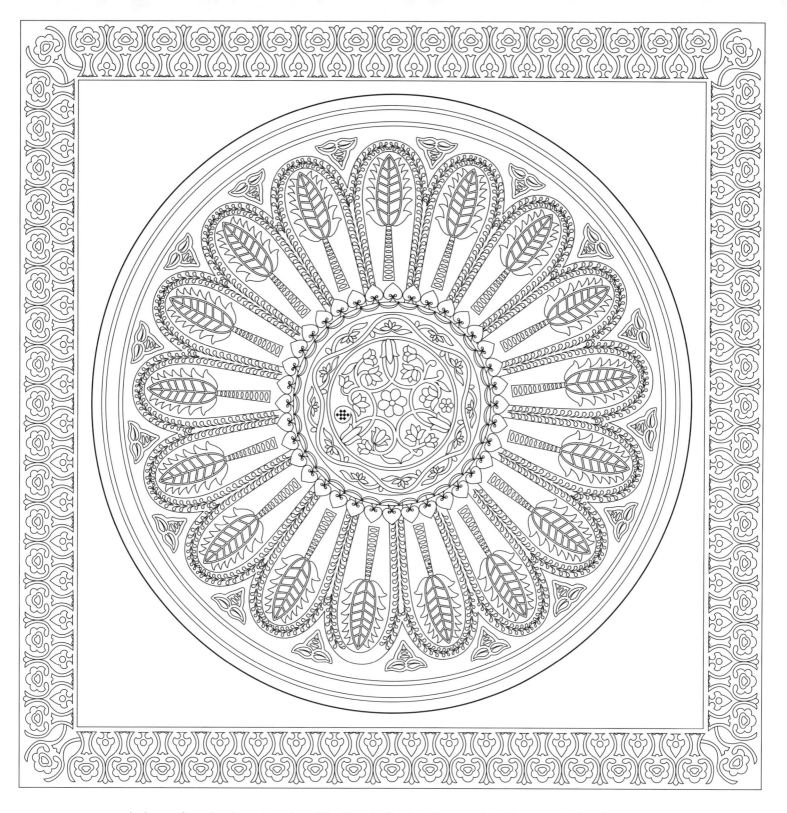

A charger from the dessert service of the Kremlin Service. The complete dinner service for 500 guests included two thousand dinner plates and took more than ten years to complete.

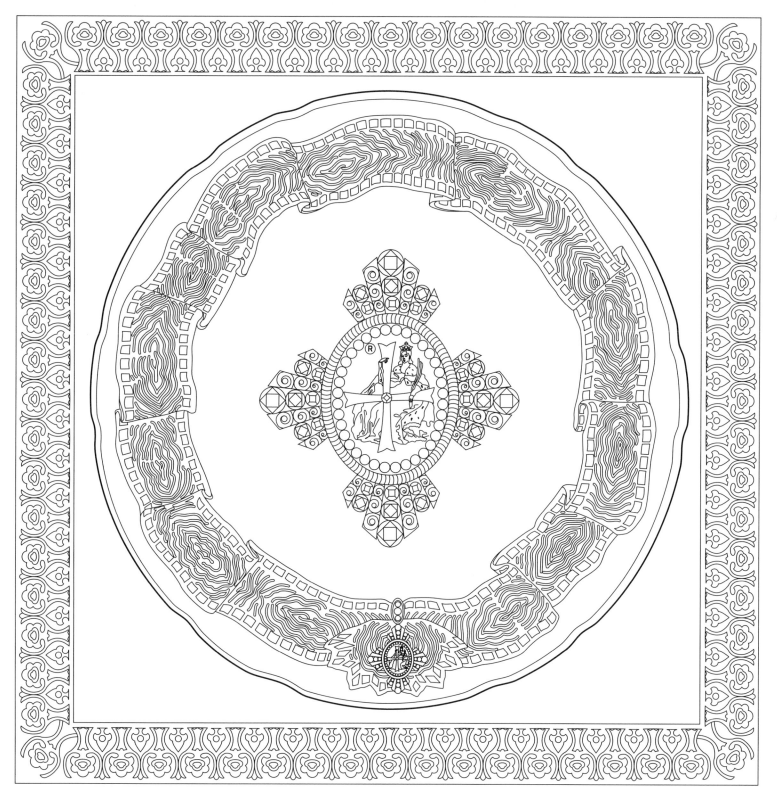

A rare plate from the Order of St Catherine Service. Porcelain services honoring Orders
were reserved for use on feast days of the patron saint.

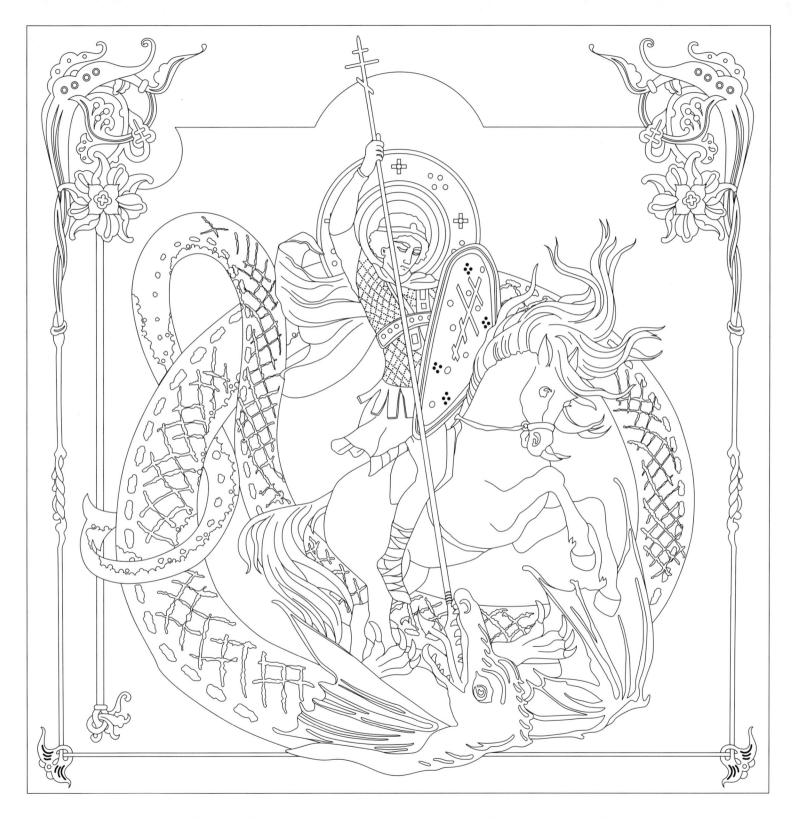

A detail from a 1904 banquet menu held at The Winter Palace: St George the Dragon Slayer.

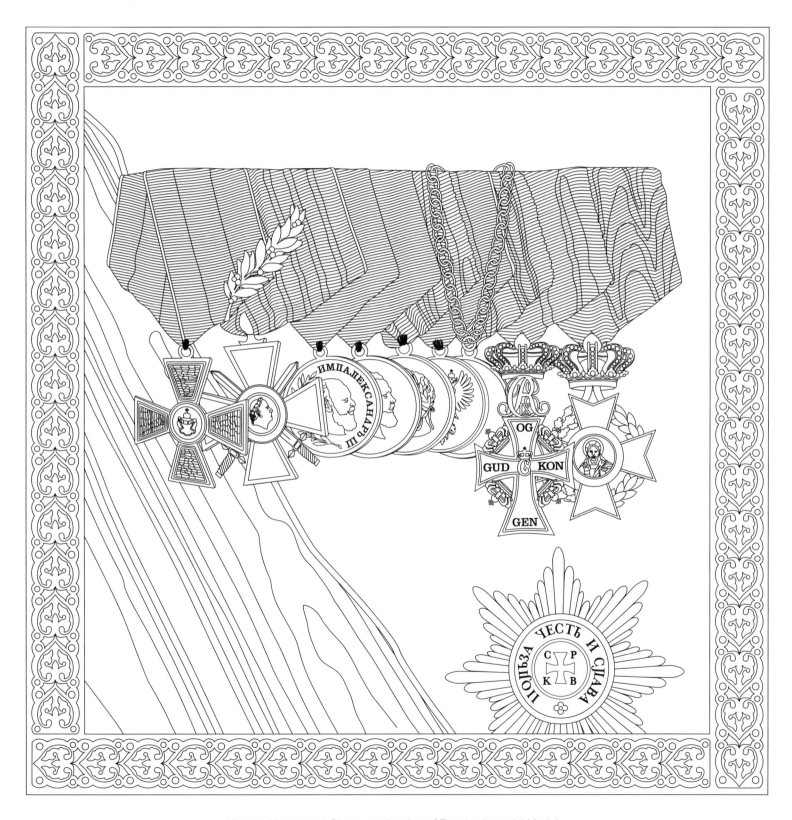

Victory, Honor, and Glory: a collection of Russian Imperial Medals.

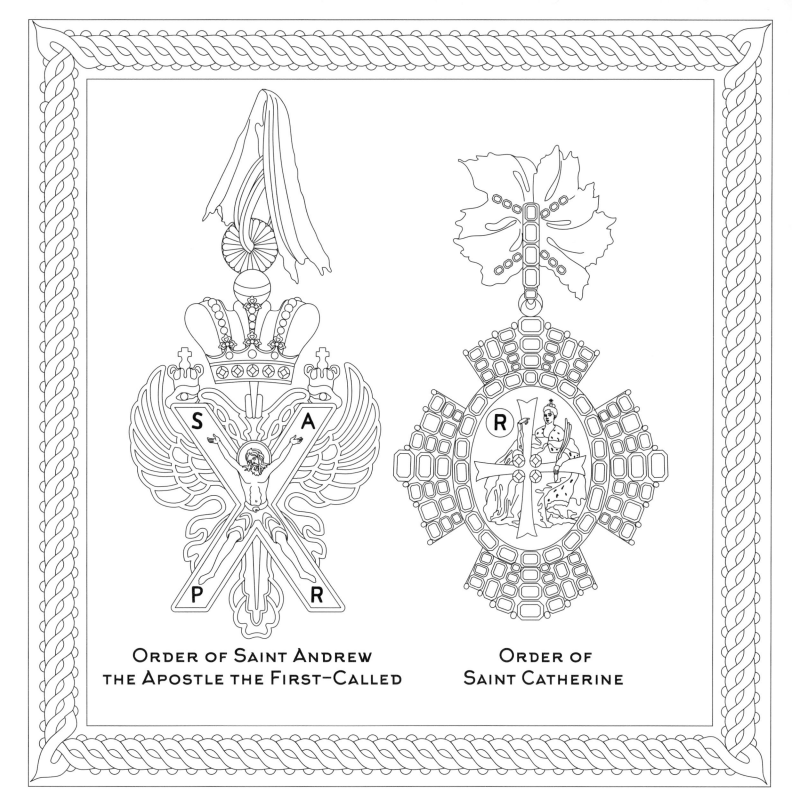

**ORDER OF SAINT ANDREW THE APOSTLE THE FIRST-CALLED**

**ORDER OF SAINT CATHERINE**

The Order of Saint Andrew was the highest order in the Empire and awarded for the most outstanding merit.
The Order of Saint Catherine was the only order of the Empire given to women.

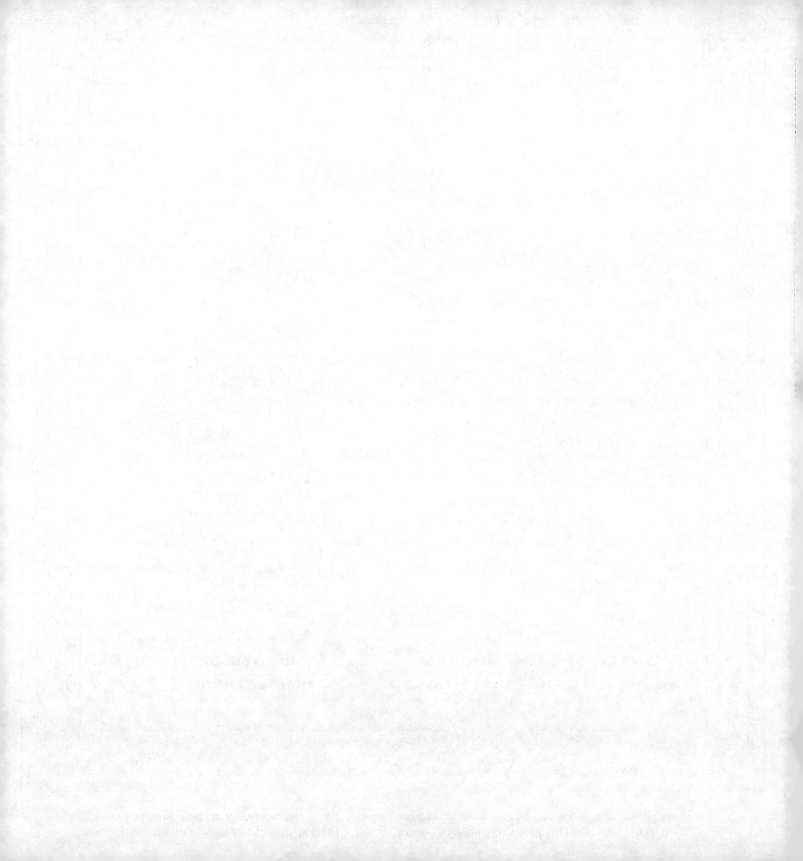

ORDER OF SAINT
ALEXANDER NEVSKY

ORDER OF
SAINT VLADIMIR

The Order of Saint Alexander Nevsky was awarded to those who served their country through political or military service.
Established by Catherine the Great, the Order of Saint Vladimir was given in recognition of continuous civil and military service.

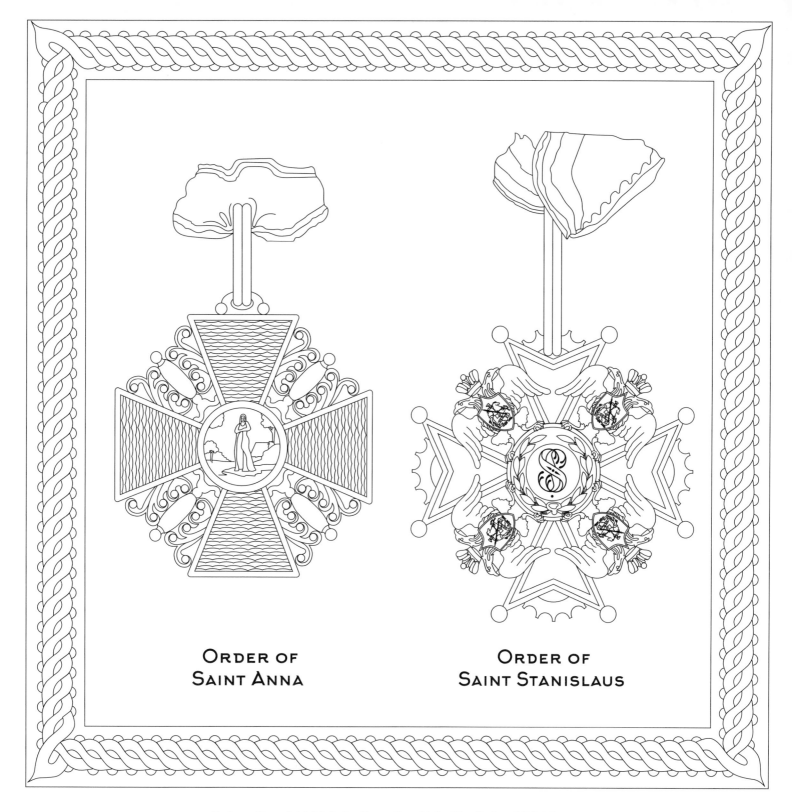

ORDER OF
SAINT ANNA

ORDER OF
SAINT STANISLAUS

By hereditary right, Nicholas II was the chief of the Order of Saint Anna.
The most junior of awards, the Order of Saint Stanislaus was the most frequently awarded.

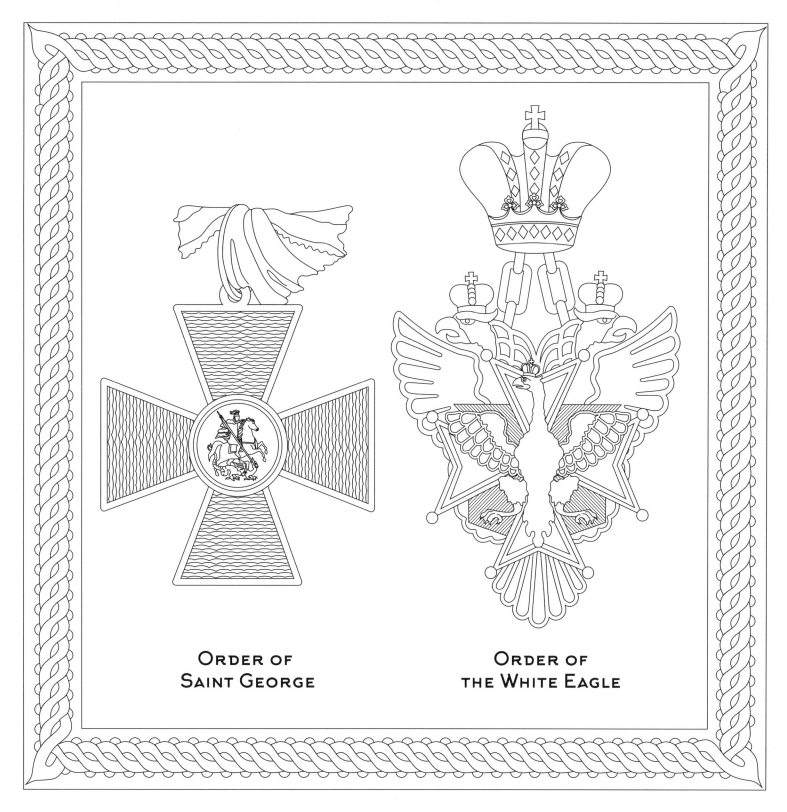

ORDER OF
SAINT GEORGE

ORDER OF
THE WHITE EAGLE

The Order of Saint George is the highest purely military award, given for protecting the Fatherland. After the
Kingdom of Poland became part of the Russian Empire, the Order of the White Eagle was given for Polish honor.

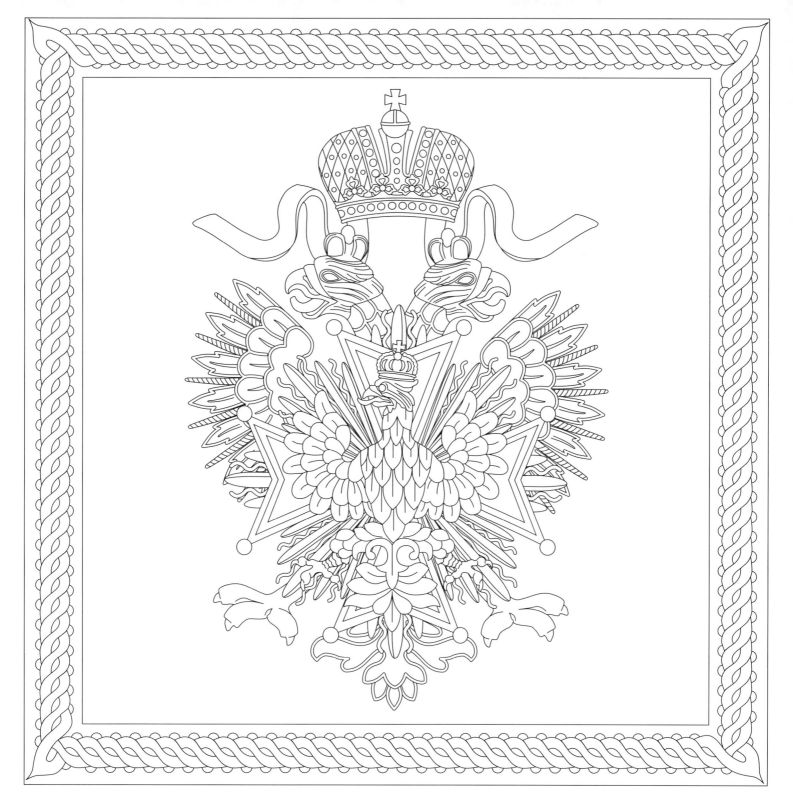

Since the top three orders of the Russian Empire were named after Russian Orthodox saints, the Order of the White Eagle was also given to non-Christians.

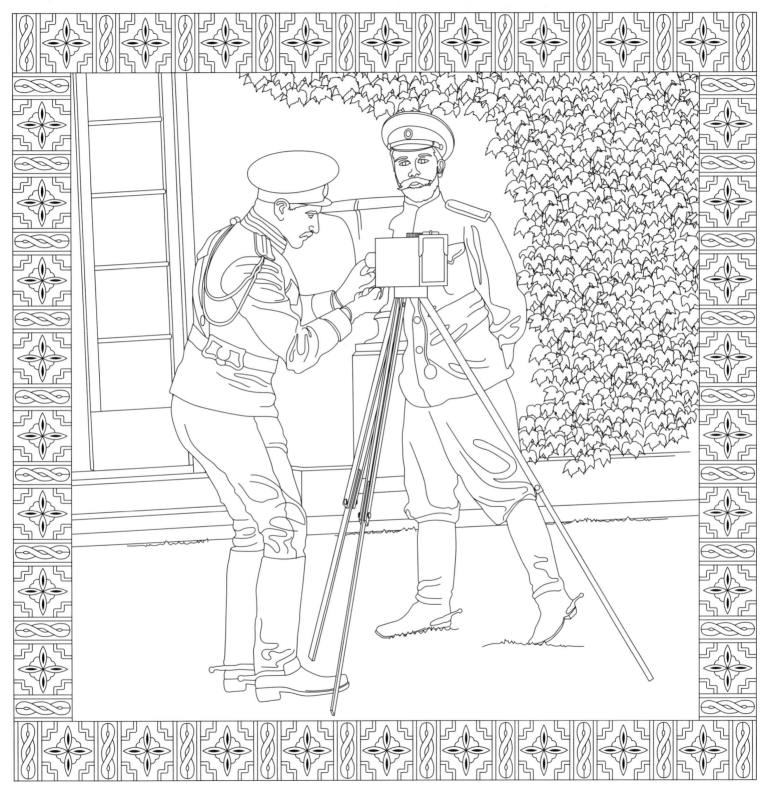

The Tsar and his family were fascinated by the latest technology of the day—photography—and possessed numerous Kodak Brownie cameras. They left behind some 140,000 family photos, numerous personal diaries, and thousands upon thousands of letters.

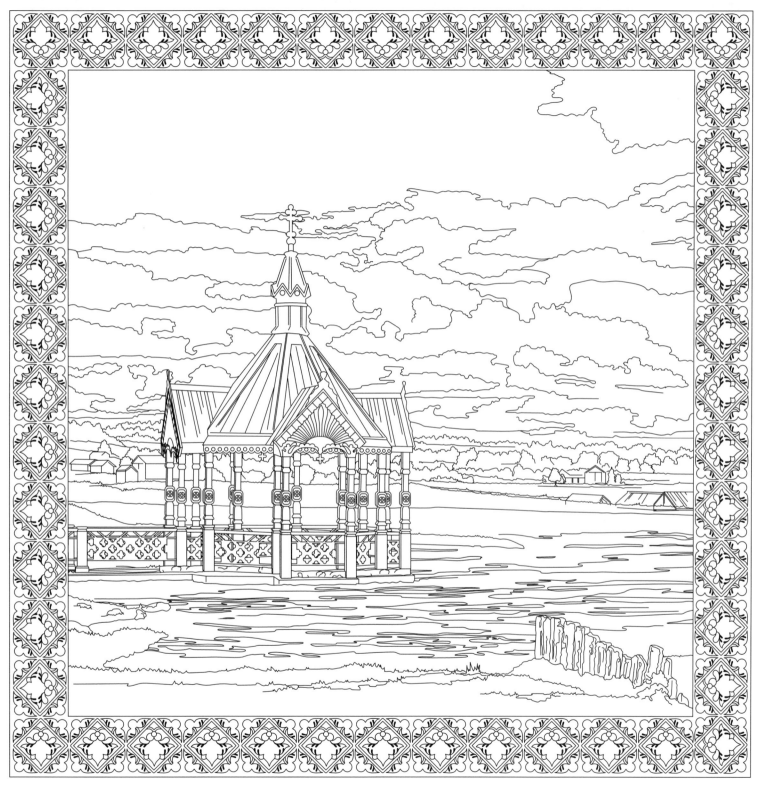

With the support of Nicholas II, Sergey Prokudin-Gorsky launched an ambitious and pioneering project to capture the vast Russian Empire in color photographs. This image, from a 1909 photo, shows a chapel for the blessing of water in the remote village of Deviatiny.

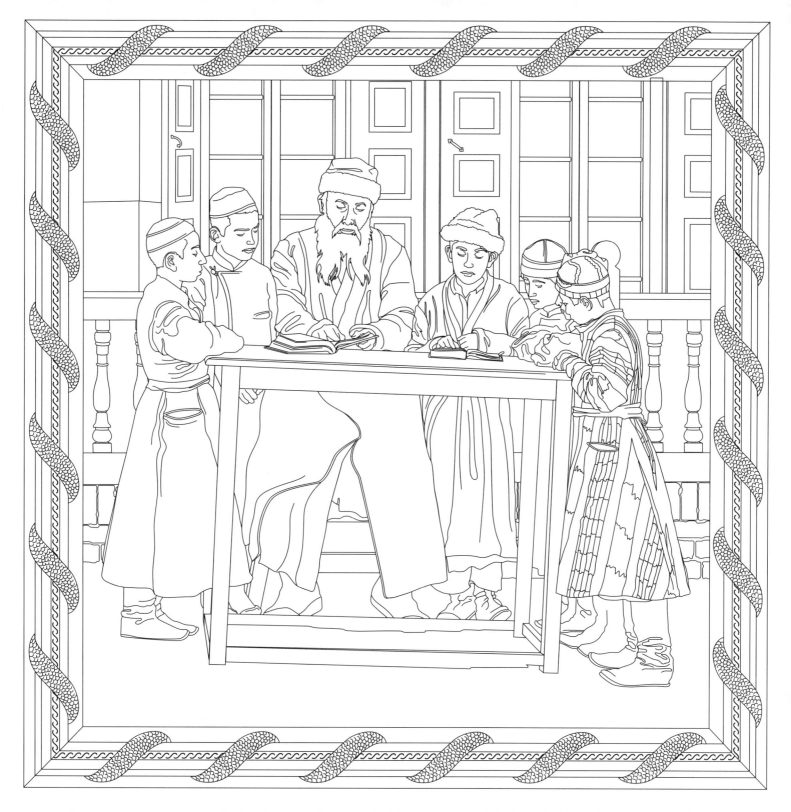

The Russian census of 1897 was the first in the Empire and took eight years to complete. It counted 125 million subjects and some 170 ethnic groups, including these young Jewish students in Samarkand, captured in a rare color photograph by Sergey Prokudin-Gorsky.

Nicholas II's Russia was bursting with creativity, as seen in this costume design for *The Firebird*, a ballet by Igor Stravinsky. It was first performed in 1910 by the Ballets Russes in Paris.

Imperial Russia gave the world some of our greatest masterpieces, including Tchaikovsky's ballet, *The Sleeping Beauty*.
Leon Bakst did this costume design for The Wolf for a later production in Paris.

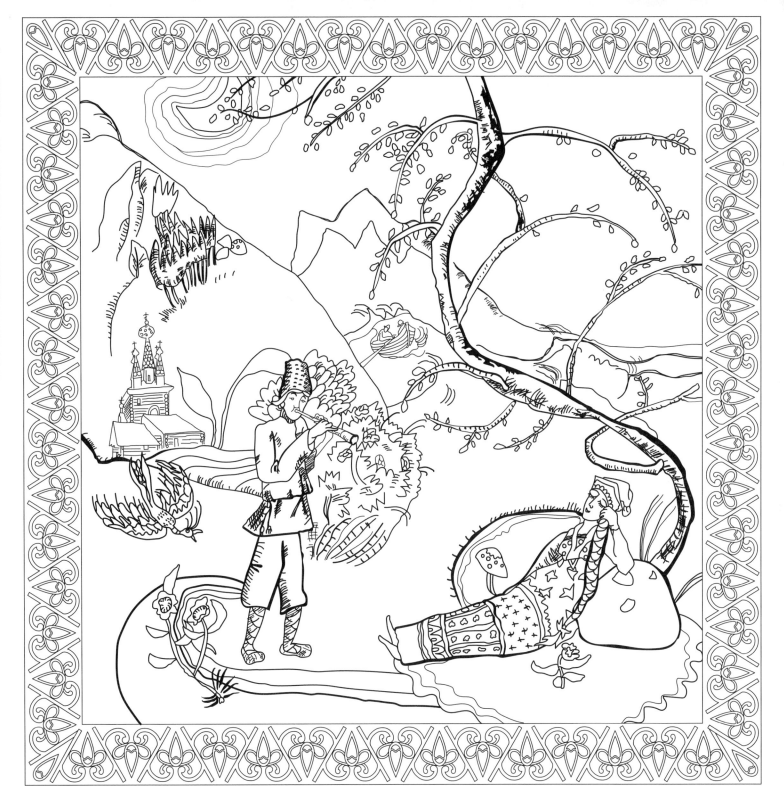

Artist Wassily Kandinsky, born in Moscow, was fascinated by the shimmering colors of the Russian countryside, as seen in this piece from 1915. He was destined to become one of the great abstract painters of all time.

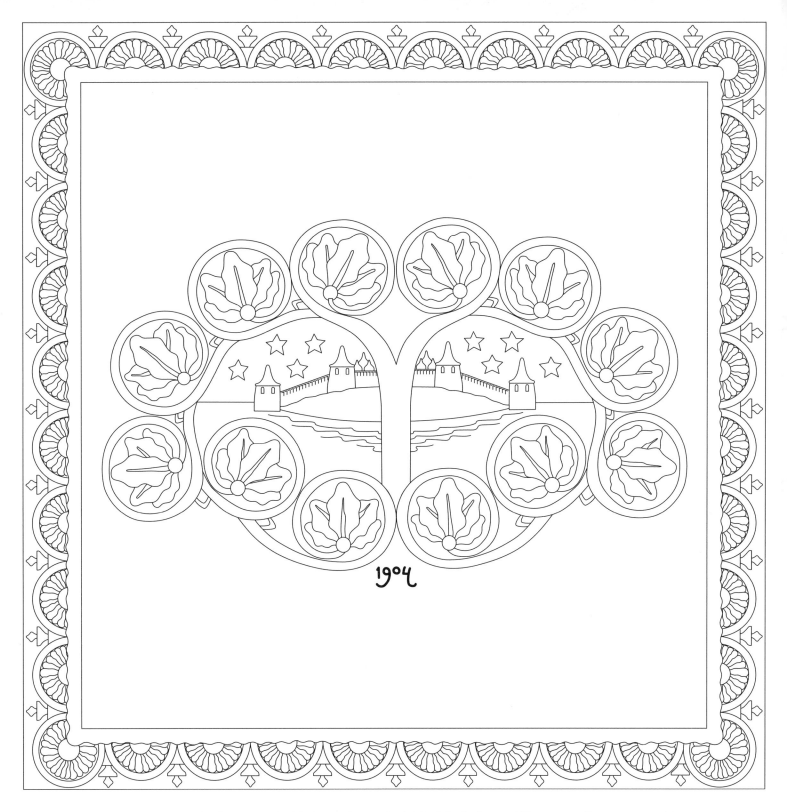

The word "kremlin" refers to any fortified complex or citadel, be it in the heart of Moscow or distant countryside.

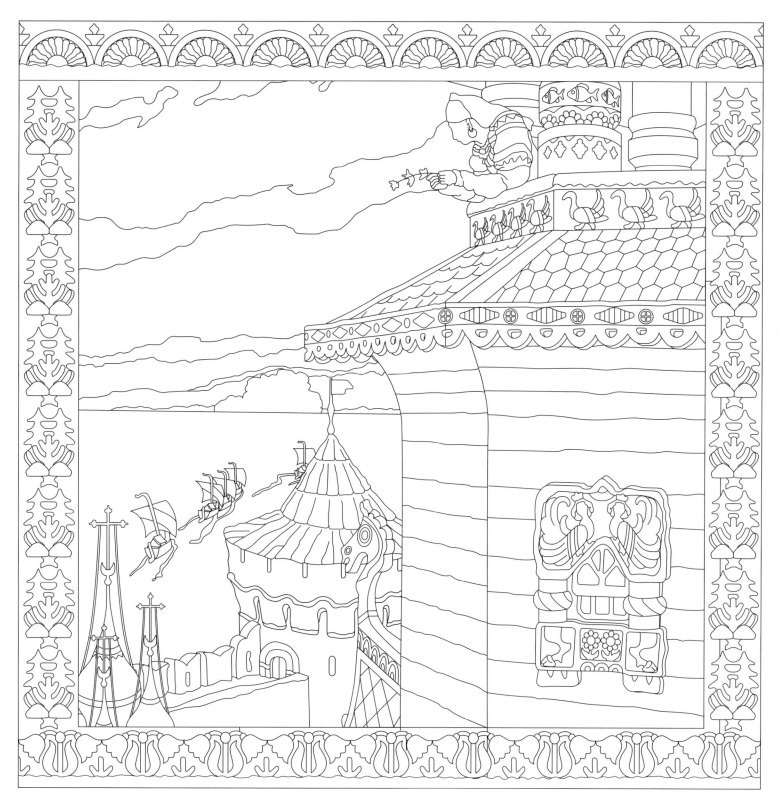

Illustrator and set designer Ivan Bilibin seamlessly blended folk art with Art Nouveau style, here in *The Princess in the Tower*.

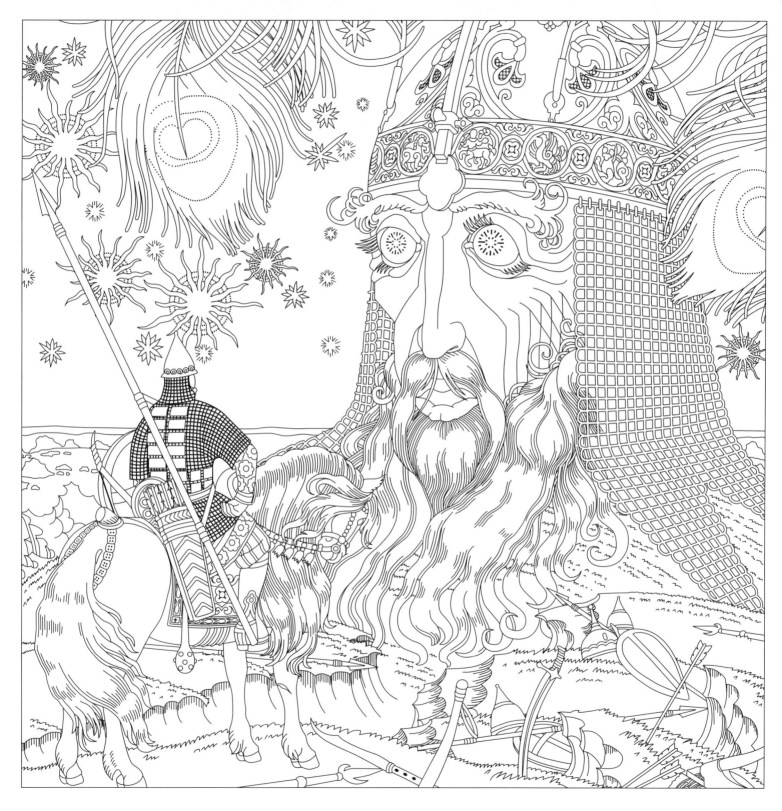

Alexander Pushkin remains Russia's most celebrated author. In 1820 he published the epic poem *Ruslan & Ludmila*,
which Ivan Bilibin illustrated in 1917. Here, the brave soldier Ruslan confronts The Head in his search for the abducted Ludmila.

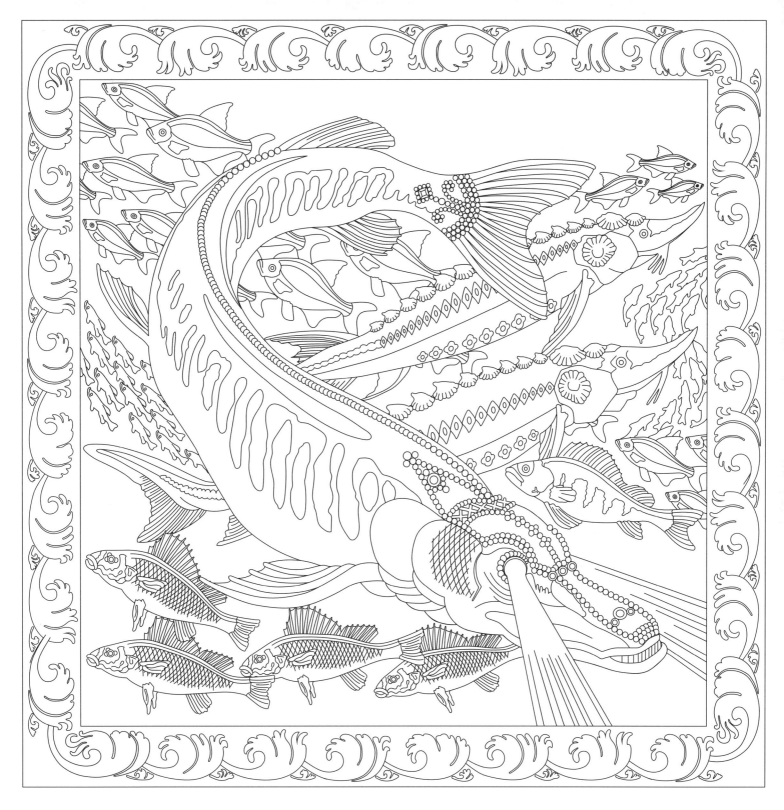

Much of Russian visual art was historically influenced by the graphic quality of its icons, which told the history of religion through visual imagery. Here, artist Ivan Bilibin captures the vibrancy of the Russian seas in *The Underwater Kingdom*.

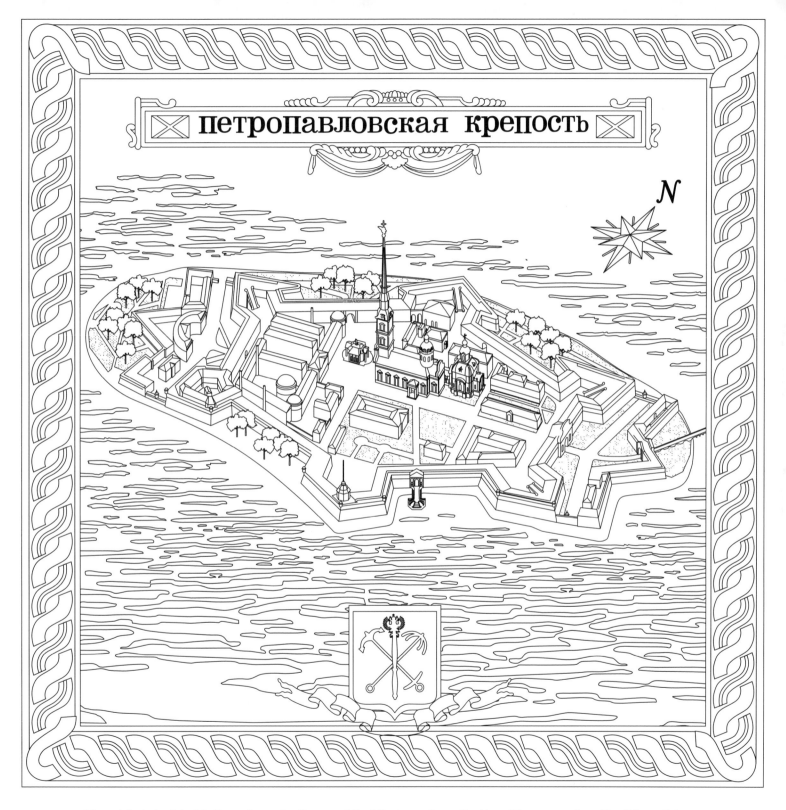

# петропавловская крепость

The original citadel of St Petersburg, the Peter and Paul Fortress sits on the Neva River across from The Winter Palace.
The Peter and Paul Cathedral at its heart is the final resting place of the Romanov tsars.

# FALL UNDER THE SPELL OF FOLKLORE AND FAIRY TALES ALL OVER AGAIN IN THIS GORGEOUS COLORING BOOK FOR ALL AGES.

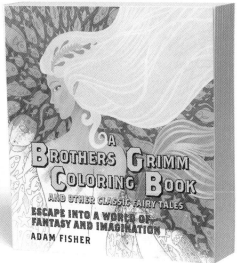

**Rapunzel. Hansel and Gretel. Cinderella. Sleeping Beauty. Snow White. We've known these characters since we were children, but in this elegant coloring book, these characters are waiting to be brought back to vivid life, through the magic of coloring.**

With a fresh new design for each week of the year, along with inspiring quotations, *A Year in Color* is 365 days of brilliant motivation.

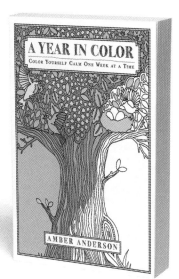

Experience your year from a colorfully calm and collected perspective with Amber Anderson's beautiful illustrations. Each week you'll find a new illustration, complete with a page for your creative doodles and flashes of inspiration, one week at a time.

For more information about these and other books, go to www.pegasusbooks.com.